UNIVERSE SERIES ON WOMEN ARTISTS

Frida Kahlo

UNIVERSE SERIES ON WOMEN ARTISTS

Frida Kahlo

SARAH M. LOWE

UNIVERSE

For E.E.

Front cover:
Frida Kahlo (1907–1954)
Self-Portrait with Loose Hair, 1947
Oil on masonite, 24 x 17¾ cm.
Private Collection

Designed by Christina Bliss

Published in the United States
of America in 1991 by Universe
300 Park Avenue South, New York,
NY 10010

91 92 93 94 95 / 10 9 8 7 6 5 4 3 2 1

Printed in Hong Kong

Library of Congress Cataloging-
in-Publication Data

Lowe, Sarah M.
 Frida Kahlo / by Sarah Lowe.
 p. cm. — (Modern women artists)
 Includes bibliographical references.
 ISBN 0-87663-607-5 (pbk.)
 1. Kahlo, Frida Criticism and
 interpretation. I. Title.
 II. Series.
 ND259.K33L69 1991 91-8331
 759.972 — dc20 CIP

Contents

ACKNOWLEDGMENTS

I owe a large measure of gratitude to Lucienne Bloch, Shifra Goldman, Solomón Grimberg, Elena Poniatowska, Carla Stellweg, Edward J. Sullivan, and Mariana Yampolsky, who warmly and generously shared their many insights about Frida Kahlo and Mexican art, as well as to Hayden Herrera who kindly opened her extensive archives to me. My work has benefitted from conversations with Suzaan Beottger, Susan Felleman, and especially Virginia Rutledge. I would also like to thank Aline Brandauer and Eve Sinaiko for their helpful comments on early stages of this manuscript. Janet Nustad and Camille Davis have been invaluable proofreaders. Teresa Carbone has my infinite gratitude for her support throughout this project.

Research for this book was facilitated by the generosity of Maria Balderrama, Nancy Malloy, and Laurie Wilson; the librarians and staff at the Museum of Modern Art, New York; Genie Candau, librarian at the San Francisco Museum of Modern Art; Amy Hau at the Isamu Noguchi Foundation, as well as by the perseverance of my research assistant, Laura Albritton.

The staff at Universe Publishing has been extremely helpful and delightful to work with. Thanks should go especially to Bonnie Eldon for her dedicated work. My editor, Adele Ursone, deserves very special thanks for her perceptive suggestions, good humor, and unflagging confidence in this project.

INTRODUCTION

What would happen if one woman told the truth about her life? The world would split open.[1]

Muriel Rukeyser

For Frida Kahlo the truth lay not so much in her life, but in her affirmation of self. Her most intensely scrutinized subject was herself: between 1926, the year she painted her first work, and her last attempts to paint during the year of her death, 1954, Kahlo produced over 55 self-portraits, in independent images or in vivid tableaux, in an oeuvre of only 143 known paintings. But Kahlo's "truth" was not simply a transcription of biographical fact; she transformed her life experiences through a personal symbolism, which nevertheless

transcended the private and addressed universally pertinent issues. Kahlo drew her complex imagery from indigenous sources as effectively as she did from European-derived colonial precedents, and she deftly combined Christian with Aztec symbolism, all by means of revaluing metaphors and generating new interpretations.

It is the aim of this text to place Kahlo's artistic production within larger art movements and yet still acknowledge the specificity of her own particular point of view and her own life. Rather than present a comprehensive view, this volume is intended to provoke further thought about Kahlo's work by exploring her relationship to artistic production in Mexico and abroad, by investigating the personal connections she made between Mexico's past and the Mexican society she lived in, and by sketching her construction of self through an examination of her work.

There is a degree of difficulty involved in recasting a biography when versions of that life are so widely accepted. Kahlo has been venerated for her proto-feminist resistance to patriarchal constraints and mythologized for her steadfast introspection in the face of the predominant "public" art of her time. In Mexico and among the Chicano and Hispanic communities in the United States, Kahlo has become a cult figure. In the border town of Tijuana, for example, one artist has created Sta. Frida, the patron saint of children and of undocumented women and undocumented art exhibitions.

A more difficult problem to overcome is the insidious way in which her biography has obscured her art. Kahlo's paintings have recently undergone a dramatic reassessment, and the interest in them has been accompanied and fueled by an almost prurient fascination with her life. Kahlo's work, which is manifestly auto-biographical, is often cast in a cause-and-effect relationship to her biography, and thus her artistic development and connections to other art practices in the twentieth century are overlooked. The outstanding aspects of her life—overcoming physical handicaps and constant pain, resignation in the face of her husband's infidelities, and a morbid obsession with her inability to bear a child—take on epic proportions and make the fact of Kahlo's producing any work at all appear nothing short of miraculous. She continues to be perceived as peripheral to the mainstream because her work has become unequivocally equated with her biography. She perpetually embodies the condition of "the other"—not male, not Anglo, not whole, not verifiably heterosexual—an artistic curiosity.

How Kahlo formulated her aesthetic is an aspect of her work rarely explored. Her knowledge of art, both historical and contemporary, was formidable, and though her art education was eclectic and sporadic, her appetite for all aspects of the visual arts was expansive. The argument that Kahlo's work emerges directly out of her physical and emotional suffering has obscured her sophisticated assimilation of various visual stimuli. Kahlo's paintings, especially her self-portraits, created a rupture in the history of art by overturning

expectations of the image of woman in art. Kahlo's radical structuring of her self, her actual self-construction, marks a resistance to objectification rarely seen in art. She is, ironically, both the subject and the object of her own gaze.

Kahlo's explorations of popular and indigenous art, as well as her recourse to colonial imagery, allow her to identify with her Mexican heritage; they also reflect her decision to contrast herself with her male contemporaries. Her Mexicanidad is richer and more complex than has previously been recognized: she drew not only from the ancient past but from contemporary models as well, not simply as visual resources but for personal and spiritual sustenance. What is even more striking is Kahlo's transformation of colonial sources into meaningful symbols. At a time when the political left celebrated the indigenous as a way of establishing a continuity with Mexico's past, the political right embraced the country's colonial heritage to offset the turbulence of the Revolution. Kahlo adroitly revitalized sources that elitists on the right coopted as a fond reminder of the stable social order under Díaz.

The undeniable fact that Kahlo's work is disturbing is often ascribed to her icono-clastic imagery: bloody births and equally bloody deaths, fetuses, corpses, and disembodied organs. Neither did she shrink from depicting herself in a less than decorous manner: rendering her slight mustache, insolently holding a cigarette, or cross-dressing. Yet the tension in the work is not due solely to the content but in large part to its style. Kahlo's highly controlled, tiny brush strokes, realistic execution, and inclusion of minute details work together to create a stark contrast to the violent and subversive motifs in her work. Moreover, in many of her portraits Kahlo's masklike face contrasts starkly and disturbingly with the mood of angst.

When Kahlo says, "I painted my own reality," she is indicating not simply that she relied on biography but that she constructed herself in her paintings. It is precisely Frida Kahlo's relentless endeavor to produce a meaningful way to situate herself that this monograph will explore.

1. Cited in Betty Ann Brown, "Autobiographical Imagery in the Art of Los Angeles Women," *Yesterday and Tomorrow: California Women,* ed. Sylvia Moore (New York: Midmarch Arts Press, 1989): 119.

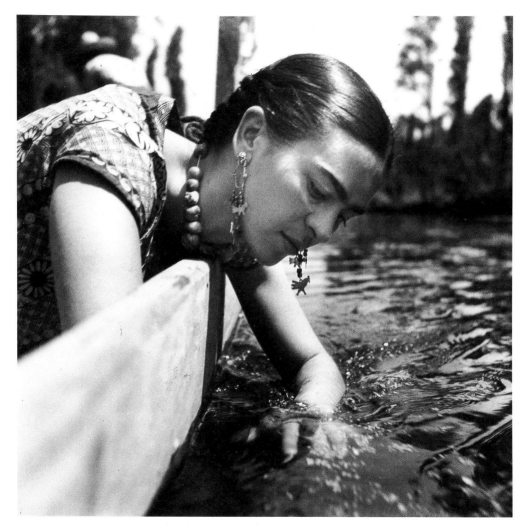

Figure 1
Frida Kahlo in Xochimilco, 1937
© Fritz Henle / Photo Researchers

BIOGRAPHICAL OVERVIEW

Frida Kahlo was born July 6, 1907. Yet she often cited 1910 as her birth date, not to make herself younger, but rather as an indication that she saw herself as a daughter of the Mexican Revolution. Kahlo's own heritage — biological, cultural, historical — is one of the most salient themes running through her work. In 1936, Kahlo depicted her family tree in *My Grandparents, My Parents and I* (plate 1), a decade into her painting career. It stands as one of the most literal examples of the moving force behind her work: the representation of her relationship with others and with the world. Kahlo relentlessly sought to establish her identity, and in this image she refashions the notion of a family tree and inserts portraits of her ancestors. Kahlo places a young self in the

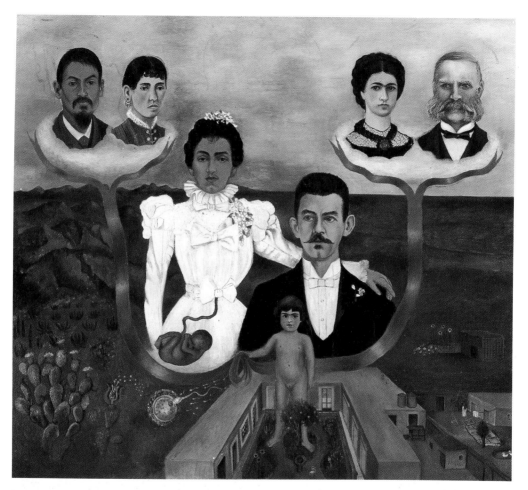

Plate 1
*My Grandparents, My Parents
and I (Family Tree)*, 1936
Oil and tempera on metal
panel, 12⅛ x 13⅝ in.
Collection, The Museum of
Modern Art, New York, NY
Gift of Allan Roos, M.D., and
B. Mathieu Roos

center, firmly planted in the "Blue House," as it became known, the home her father built in 1904 in Coyoacán, the historic suburb of Mexico City that dates back to precolonial times, where she was born and grew up.[1]

The family into which she was born included two older sisters, Matilde and Adriana, and two half-sisters, María Luisa and Margarita, from her father's first marriage, who lived in a convent. Her younger sister, Christina, was born a year after Frida. The Kahlo family lived relatively well in their gracious surroundings, in spite of financial troubles caused by the Revolution.

In *My Grandparents, My Parents and I,* the young Frida holds a blood-red ribbon in her hand, signifying her descent. Her parents, painted from a wedding portrait, dominate the image: Matilde Calderón y González, a devout Catholic mesitza, and Guillermo, a German Jew of Austro-Hungarian descent. Had she lived to see this image, Matilde would surely have been scandalized by Frida's scientific depiction of a fetus — Frida at six months — superimposed upon her mother's wedding dress, and below that, a vignette of fertilization — Frida at conception.

In the upper left of the painting, Frida's maternal grandparents hover above an expanse of volcanic rock, the rocky *pedregal* that Frida painted so often, characteristic of parts of the Mexican landscape. Here, as in her other work, it indicates her strong connection to the land, a specific reference to her Mexican heritage. Frida's creole grandmother was the daughter of a Spanish general and her grandfather, a photographer, was of Indian descent. Both her precolonial and her Indian heritage became important themes in Kahlo's work, and she developed a visual and symbolic vocabulary that allowed her to celebrate her Mexican ancestry.

On the other side, her paternal grand-parents float above the ocean, which marks their link to Europe. Guillermo Kahlo, Frida's father, was born in 1872 in Baden-Baden. His father, a dealer in photographic supplies, presumably taught his son the craft of photography. Guillermo emigrated from Germany to Mexico at the age of nineteen. During the early years of the century he was commissioned by the Díaz government to photograph religious and civil architecture of the colonial period throughout Mexico, as well as to document the principal buildings constructed during the "Porfiriato" dictatorship in preparation for Mexico's centennial celebration of inde-pendence.[2] Guillermo's most celebrated project was a six-volume collaboration with Dr. Atl (Gerardo Murillo) documenting the churches of Mexico. Kahlo was also an amateur painter.

In 1951, ten years after her father's death, Frida painted the haunting *Portrait of My Father* (plate 2) from his photographic self-portrait. Below his image, in an expres-sion of devotion, her dedication reads:

> I painted my father Wilhelm Kahlo, of Hungarian-German origin, an artist-

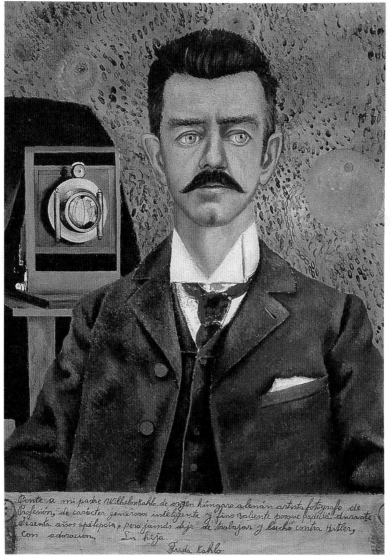

Plate 2
Portrait of My Father, 1951
Oil on masonite, 23⅛ x 18⅜ in.
Collection, Museo de Frida
Kahlo, Mexico

photographer by profession, in character he was generous, intelligent and fine, valiant, because he suffered during sixty years from epilepsy, but never ceased working and fighting against Hitler, with adoration, his daughter Frida Kahlo.

The portrait is striking in the way in which Guillermo's eyes fail to reach the viewer (Frida, in her self-portraits always addressed the viewer forthrightly). The agitated brush strokes in the background bring to mind the turbulence of many of van Gogh's portraits. Kahlo includes strange circular shapes, suggestive of biological drawings, alluding to her father's tenuous hold on his good health. Frida shared with her father an intensity, industriousness, and fastidiousness. Both were introspective and both suffered from ailments their whole lives. When Frida was six, she contracted polio and was laid up for nearly a year. The disease took its toll: she was left with one leg shorter than the other, a deformity that made her always self-conscious. Even more damaging were the trophic ulcers she suffered from throughout her life. Ultimately they became infected with gangrene and caused her right leg to be amputated shortly before her death.

In 1922 the fifteen-year-old Frida was sent to further her education at the National Preparatory School (Preparatoria) in the heart of Mexico City. Kahlo was on her own for the first time, competing with students who were to become eminent in art, literature, scholarship, law, and medicine.

During her two years at the Preparatoria, Kahlo met like-minded students and became part of a precocious, rebellious group of students who called themselves the Cachuchas after the caps worn at the school. Their intellectual vitality was mixed with a large measure of contempt for authority. It was here that Kahlo first came into contact with the driving cultural forces in modern Mexico and the modern world that prepared her for her future.

Kahlo's years at the Preparatoria occurred at the beginning of the post-Revolutionary period, as the ideas and values of the thirty-four-year dictatorship of Díaz were discarded, and Mexico experienced a cultural renaissance stimulated by social reforms. The intelligentsia rejected European civilization as a model and embraced a new political order along with new forms of art, all subsumed in a nationalism that had at its heart a revaluing of Mexico's indigenous heritage.

As one of a handful of female students who attended the prestigious Preparatoria, which until recently had been exclusively male, Kahlo developed a self-assurance and a belief in herself. Her aptitude for science led her to embark on a rigorous course of studies, and she intended to go on to medical school and become a doctor. In spite of the progress made after the Revolution, women doctors were a rarity: not twenty years earlier there had been only three practicing woman doctors in all Mexico City.[3] Although she did not become a physician, her studies in biology and physiology bore fruit later, for they

provided her with an important and potent vocabulary in her painting. Kahlo made use of medical analogies and metaphors, often picturing—outside the body—hearts, glands, and other organs or displaying a kind of x-ray knowledge of veins and ducts.

A near-fatal accident that changed Kahlo's life occurred in September 1925, when the bus she was riding home to Coyoacán from the Preparatoria collided with a trolley car. The impact caused a metal handrail to break loose, and the eighteen-year-old girl was pierced through the pelvis: "I lost my virginity," she said with typical irony.[4] Kahlo was lucky to survive: she sustained numerous breaks in her pelvic bone, spinal column, and collar bone; several ribs were cracked; her right leg was broken in eleven places, and her right foot was crushed. Although she recovered enough to lead a fairly normal life, the accident had deep psychic and physical consequences: her professional plans had to be abandoned; she had to recognize that she would be a semi-invalid the rest of her life; and her brush with death, her intermittent pain, and her frequent operations brought a new sensibility to one already unorthodox—she developed a critical and perceptive mind and had little tolerance for affectation and an uncanny ability to penetrate pretension and get at the core of people and events.

Kahlo's inner resources were remarkable: exactly a year after her accident she produced her first painting, a self-portrait dedicated to her boyfriend, her *novio,* Alejandro Gómez Arias, the leader of the Cachuchas. He remembers her voracious appetite for books, which she borrowed from her father's library—a collection which was typical of an educated German—as well as from the Ibero-American Library.[5] Her interests were wide: she read Russian novels as well as the *Revista de Occidente* edited by José Ortega y Gasset and filled with current Modernist literature and philosophy. Most significantly, perhaps, Kahlo sought out any book about art, and this informal, random education fed her artistic life once she began to paint, just as it had fed her imagination in her youth.

Kahlo's visual guidance had begun a few years earlier, under her father, who taught her, when she asked, how to use a camera, develop film, and touch-up and hand-color photographs. Although the exactitude of the photographic image may have appealed to her, she was indifferent toward the mechanical aspects of the medium. The balance of her formal artistic training consisted of two required art classes at the Preparatoria and, in 1925, an apprenticeship with Fernando Fernández, a commercial engraver. His instruction consisted of having Kahlo copy etchings by the Swedish artist Anders Zorn, whose favorite subjects were female nudes and portraits of fin-de-siècle intellectuals like Strindberg, Verlaine, and Rodin. Fernández was impressed with Kahlo's prodigious talent: when she was motivated, she could paint watercolors of remarkable verisimilitude, images that virtually came off the page. Indeed, at one point she had considered scientific illustration as a profession.

But Kahlo's preferred cartoon-like style,

though less accurate, was infinitely more expressive and original. Her stylized, seemingly unsophisticated manner is evident in the nearly twenty portraits and four self-portraits she painted between 1926 and 1931. Although they are not conventional in the least, they lack the complexity of her later work. In the early thirties, Kahlo made a radical break with her stylistic past in a posthumous portrait of the horticulturalist Luther Burbank (plate 21). The major elements of her characteristic style are first stated in this painting: illusionism mixed with the fantastic tells the story of cycles of growth, decomposition, and regeneration so vital to Burbank's work.

In spite of the recurring problems of her slowly healing body, which kept her bedridden for months at a time, Kahlo kept abreast of artistic currents and began to see herself as a serious artist. She experimented with Modernist forms in *Pancho Villa and Adelita* (plate 5) from 1927. Perhaps the best evidence of her commitment to her new-found vocation was the fact that her father made photographic copies of her work, presumably at her request. Moreover, her work was scheduled to appear in the avant-garde review *Panorama* edited by one of her Cachuchas pals, Miguel N. Lira, which was to include work by Diego Rivera and poetry by Roberto Montenegro.

As Kahlo re-evaluated her professional and personal aspirations, she became more active in politics, and a year after she painted her first self-portrait, she joined the Young Communist League. Kahlo's commitment to progressive politics was memorialized by Rivera in November 1928. "Distribution of Arms," a fresco panel that decorates the walls of the Ministry of Education, is situated as the first and largest of nine adjoining sections of the *Corrido of the Proletarian Revolution*. The images are visually and thematically linked by a trompe-l'oeil banner, upon which are the words of a *corrido,* or ballad. The choice is appropriate since *corridos* were sung by itinerant performers to inform the illiterate about national events and were specifically associated with narratives of the Revolution. The fresco features Rivera's future wife working collectively with, among others, Tina Modotti, the photographer and activist; Modotti's lover, the exiled Cuban Communist student leader Julio Antonio Mella; and the muralist David Alfaro Siqueiros, an ardent Stalinist.

Kahlo's gravitation toward the Communist Party had at least two causes. First, the leaders of the Mexican Communist Party were also the leading artists of the country: Rivera, Siqueiros, José Clemente Orozco, and Xavier Guerrero. Through their politics and under the auspices of a public-art policy administered by José Vasconcelos, these artists advanced the principle of a socially meaningful art. Even though Kahlo's style and form was diametrically opposed to theirs, and despite the fact that she never yielded to social realism, Kahlo's political consciousness is evident throughout her life and work.

The Party held another attraction as well: the presence of several dynamic

women whose independence and self-direction may have encouraged Kahlo to join. For example, Modotti was involved in the production of *El Machete,* the organ of the Mexican Communists. She supported herself by taking commercial photographs of the Revolutionary murals, but she also produced art photographs with political content. Her autonomy and bohemian life represented a plausible model to which Kahlo may have aspired. Another formidable woman in the Party was Alexandra Kollontai, who came to Mexico during the autumn of 1926 as an emissary from Moscow's Communist Central Committee. The first woman ambassador ever, she represented the USSR in Norway, Sweden, and Mexico during her distinguished twenty-three-year diplomatic career. She was an ardent and articulate writer and orator, known as an impassioned opponent of Fascism as well as a champion of peace and women's emancipation. Her presence in Mexico was viewed with suspicion by American oil interests, who cautioned the Mexican government to resist all Bolshevik influence.

Kahlo's involvement in social struggle sprang from her deep sympathy for the disenfranchised and disadvantaged people of Mexico. Her commitment in many ways paralleled Rivera's, but characteristically independent, Kahlo consciously chose precisely how she would demonstrate her devotion, and she never followed the dogmatic practices dictated by the Party. In every facet of her life, Kahlo took a stance of defiance — against conventions of behavior and dress, against the circumscribed roles for women, against foreign imperialism and political oppression, and even against pain, illness, and death.

Kahlo's rebellion can, in part, be seen against a backdrop of nascent feminist activism (Mexican women only achieved full suffrage in 1958) that emerged after the Revolution.[6] Her independence, active life outside the traditional female sphere of the home, and nonconformist disposition was in consonance with the emergence of the international phenomenon of the New Woman.[7] Nevertheless, when Kahlo married Rivera in 1929 at the age of twenty-two, her preconceived notions of wifehood were abandoned, and she adjusted to life with the forty-three-year-old Rivera, Mexico's most famous artist. In spite of her self-assurance and strong personality, in letters, diaries, and even her painting, Kahlo reveals deeply felt conflicts about her role as Diego Rivera's wife, a role she took quite seriously.

Throughout their married life together, Kahlo tried to balance her devotion to Rivera with the pursuit of her own aspirations. On the one hand, she took responsibility for much of Rivera's extensive correspondence, either typing his dictated letters or writing on her own; she shopped for household supplies and food; she delivered lunch to Rivera — who was usually at work on a mural — and tended him through bouts of illness as well as fits of hypochondria; and she handled their finances. On the other hand, she continued to paint. Kahlo's generation was the first to

bring a significant female presence to the visual arts. Among Mexican women artists working in the thirties were María Izquierdo and Olga Costa, and the foreign-born artist Modotti, and in the forties, emigrés Leonora Carrington, Remedios Varo, Kati Horna, and Alice Rahon. However, until 1936, when Aurora Reyes received a commission, no Mexican women had participated in the mural movement. Curiously, only non-Mexicans, (Americans Marion and Grace Greenwood, Ione Robinson, among them) who came to Mexico in the twenties and thirties found walls to paint on.[8] Exclusion from the fresco movement meant that women painters produced mostly easel painting, which was less valued in Mexico than the ascendent public art.

Shortly after Kahlo and Rivera married, Rivera accepted the post of director of the Academy of San Carlos. This offer from the increasingly anti-Communist Mexican government had the effect of neutralizing him politically, and Rivera was expelled from the Communist Party. The hard line of the Party may have been, at this point in Rivera's life and career, incompatible with his growing international status. Though Rivera always remained sympathetic to Communism, by the thirties his politics of art were at odds with his earlier beliefs: where before he had disparaged all non-public art, now he accepted capitalist dollars from North American patrons who paid him for drawings and oil paintings. It was thanks to several significant mural commissions awarded Rivera that Kahlo traveled to San Francisco in November

1930 and spent almost three years in the United States. Here she came into contact with high society, North American style. The matrons and patrons of California, Detroit, and New York, anxious to associate themselves with this latest novelty, fascinated Kahlo as much as they offended her sensibilities. "Gringolandia" is how she came to think of her northern neighbor, and in several perceptive paintings Kahlo depicts the conflicting emotions she felt living in the United States.

During her three years in the United States, Kahlo devised ways to be Rivera's wife and as well as an artist in her own right, and she produced about a dozen works. Her art education continued, and her level of sophistication was enhanced by travel. While Rivera was at work at his murals, Kahlo had the opportunity to visit museums and collections in the host cities. She also met many artists, and it must have been encouraging to encounter a number of committed, serious women artists. In San Francisco she met and was photographed by Imogen Cunningham; in New York at Alfred Stieglitz's gallery she met painter Georgia O'Keeffe and lived in the same building as sculptor Louise Nevelson; in Detroit she became very close friends with Lucienne Bloch, who accompanied her to Mexico in 1932 after Kahlo received word that her mother was ill. Though none of these women seem to have had any effect on her work stylistically, their presence in the arts may well have fostered self-reliance in the twenty-five-year-old Kahlo. In fact, it was through the San Francisco Society of

Women Artists at their Sixth Annual Exhibition—held at the California Palace of the Legion of Honor in November 1931 —that her work was first seen in public.[9]

Kahlo painted intermittently during this period, alternately peeved and charmed by Gringolandia. In addition to producing portraits of several society women she met, twice she formulated elaborate self-portraits with scenes contrasting Mexico with the United States: *Self-Portrait on the Border Between Mexico and the United States* (plate 6) and *My Dress Hangs There.* Her most remarkable paintings during this period were *Portrait of Luther Burbank* (plate 21), *Henry Ford Hospital* (plate 17), and *My Birth* (plate 8), which, with their intensity and subject matter, indicate the emergence of Kahlo's mature themes.

After three years of living in hotels and rented apartments in the United States, Kahlo longed to be back in Mexico. Rivera, however, in spite of a series of devastating professional setbacks—the destruction of his Rockefeller Center mural and the withdrawal of a major commission to be featured at the General Motors Building at the Chicago World's Fair—felt the United States offered better professional opportunities. In this contest of wills, Kahlo won what turned out to be a Pyrrhic victory. Upon their return to Mexico in December 1933 Kahlo and Rivera moved into a double house designed by Juan O'Gorman which Rivera had commissioned in the suburb San Angel, a community neighboring Coyoacán. Frida and he each had their own house, connected by a bridge, an apt metaphor for their subsequent life together. This was a time of discord and anguish as Kahlo wrote in letters to her friends: Rivera was depressed, unable to work, and resentful of being back in Mexico; while Kahlo, feeling guilty and trying to support him, was helpless to change anything. Their marriage became strained, and during the next few years they both turned outside their relationship for emotional support and sexual pleasure.

Kahlo was unfettered by the conventional sexual mores of her parents' class and generation and had a healthy, progressive attitude toward sex. Kahlo had come of age during the 1920s, and the new sexual permissiveness of the era suited her. She understood that sexual freedom meant more than the license to take lovers: it meant the ability to enjoy her sexuality without remorse or recrimination, in other words, to take the same pleasures men had traditionally enjoyed. Rivera's liaisons with other women may have troubled her, but she herself engaged in sexual relations with other men and women during her marriage. It is doubtful Kahlo was looking for someone to replace Rivera. More likely, her extra-marital love relationships were genuinely loving, not breaches of trust but the fulfillment of mutual desires. Although Kahlo and Rivera were, above all, fierce individuals who respected each other and each other's privacy, a double standard still existed. Most of Kahlo's love affairs were private matters, whereas Rivera had a well-known reputation for womanizing. By all accounts, Rivera seems

to have ignored Kahlo's liaisons with women, while she kept her affairs with men secret.

The period following her return from the United States was not productive for Kahlo in terms of art, but it was a rich period of personal growth. Although Kahlo and Rivera did not live together regularly after their return to Mexico, they saw each other often, participating in activities of mutual interest, meeting at parties and socializing with their old friends. Yet Kahlo remained autonomous, and in the course of forging an existence apart from Rivera, she had several affairs, some serious, others casual. Among the men she was involved with over the next few years were artist Ignacio Aguirre, sculptor Isamu Noguchi, exiled Russian leader Leon Trotsky, photographer Nickolas Muray, and future art dealer Heinz Berggruen—each dynamic, intelligent, and challenging. For example, in 1936, when she met Noguchi, who was just three years older than herself, Kahlo found a dedicated artist with a political conscience, a man of wit, humor, and charm. Noguchi not only enjoyed Kahlo's company, he was enthralled at being in a country where artists were accepted as an integral part of the social community. Under the direction of Pablo O'Higgins, Noguchi agreed to sculpt a wall at the newly renovated Mercado Abelardo Rodríguez (also called Mercado del Carmen), which he entitled *History Mexico*. This, his first major work, was a twenty-two-meter-long indictment of capitalism, showing labor triumphant.

There can be no doubt that Kahlo's liaisons were intellectual as well as physical. Yet in her heart Rivera was always the standard by which Kahlo measured her lovers, and in perfect guilessness she could write to a paramour that only Diego held a warmer place in her heart than he did.[10]

There is an interesting correlation between Kahlo's political activity and her artistic productivity, a connection that speaks to her growing maturity as an artist. Beginning with the outbreak of the Spanish Civil War in July 1936, she devoted a significant amount of time to raising money in support of the Mexican militiamen fighting on the side of the Loyalists. During the ensuing months, Kahlo worked ardently, moved, she said, by the generosity of the peasants and workers who pledged a day's pay to the cause. She, in turn, solicited financial contributions from friends abroad. Kahlo's political endeavors were intensified with the arrival of Leon Trotsky in Mexico in January 1937. Upon the agreement of the Mexican government to grant asylum to the exiled Trotsky, Kahlo not only met his boat in Tampico but invited him, his wife, and his entourage to stay at her Blue House in Coyoacán. This was no small gesture, since Trotsky was high on Stalin's hit list. Kahlo's next months were filled with public activity. She attended the Dewey Commission's mock trial of Trotsky in April, staged to determine whether the charges leveled against him in absentia by Stalinist courts were legitimate. Kahlo's relationship with Trotsky was warmer before the trial, and by the time of his acquittal in September, as he turned his

attention to the particulars of founding the Fourth International, their closeness diminished.[11]

Kahlo's proximity to these world-watched events had a sobering effect on her, and as she approached her thirtieth birthday, she became more focused about her art. Looking back on this period, Kahlo wrote in early 1938 to her lifelong friend, Ella Wolfe:

> I have [been] paint[ing]. Which is already something, since I have spent my life up until now loving Diego and being a good-for-nothing with respect to work, but now I continue loving Diego, and what's more I have begun to paint monkeys seriously.[12]

After producing nothing in 1934 (her first year back in Mexico), two works in 1935, and one only the next year, in 1937 Kahlo finished eight paintings, then fifteen more the following year. It was her most productive period, and it marks the beginning of significant public recognition. In September 1937 Kahlo was included in a group exhibition at the Galería de Arte, part of the Department of Social Action of the National Autonomous University of Mexico. The four works she showed came to the attention of the young New York art dealer Julien Levy, and in early 1938, he wrote to Kahlo asking her to show thirty works in his gallery in October of that year. It is evident from letters that Julien Levy must be acknowledged as the first person in a position to bring her to international attention to discern the significance of Kahlo's work. His perspicacity led him to offer her a one-person exhibition months before André Breton set foot in Mexico.[13] Since the early thirties, Levy had been showing works by the French Surrealists, giving one-person shows to Man Ray, Max Ernst, Alberto Giacometti, Yves Tanguy, and René Magritte.[14] Although Kahlo was not yet acquainted with him, Levy held an exhibition of Surrealism that opened in New York a month after Rivera's 1931 retrospective at the Museum of Modern Art. If Kahlo did not see the show, she had certainly heard of it before she left for Detroit, since it received wide acclaim.

Shortly after Levy wrote to Kahlo, the self-appointed leader of Surrealism, the poet and polemicist André Breton and his wife, the painter Jacqueline Lamba, arrived in Mexico. The meeting of Breton, Rivera, and Trotsky incited long, intense, and serious discussions, which, in turn, produced the famous manifesto, "Toward an Independent Revolutionary Art." Kahlo was not interested in participating in their academic, speculative, and theoretical dialogues: it was this high-falutin' nonsense that repelled her in Paris when she arrived in the spring of 1939 after her successful show in New York at the Levy Gallery. Breton was to have arranged for her work to appear at Galerie Renou & Colle, but he turned out to be a feckless ally. It was Marcel Duchamp who organized the show, which opened in March. Breton, nevertheless, managed to have his say, calling the show Mexique, and supplemented Kahlo's

painting with nineteenth-century Mexican portraits, folk art, and photographs by Manuel Alvarez Bravo. That Kahlo was not pleased with this arrangement suggests how strongly she felt that her work was "high art," in spite of her use of folk sources. Her paintings, while not appealing universally, did well in New York (twelve out of twenty-five were sold), and in Paris, the Louvre purchased *Self-Portrait: The Frame,* made of aluminum plate and glass, which Kahlo painted in order to make a portrait in the character of Mexican folk art.

Due in large part to the international exposure of her work in 1938 and 1939, Kahlo's painting career and her position as a professional artist became firmly established. Throughout the decade of the forties she was recognized by honors, awards, public and private commissions, and inclusion in numerous exhibitions. One of her largest canvases, *The Wounded Table* (known today only through photographs) was included in the International Exhibition of Surrealism at Inés Amor's Galería de Arte Mexicano that year. Between 1938 and her death, Kahlo exhibited her work in over thirty shows in Mexico, the United States, Sweden, France, England, and Peru, and she was honored in 1953 with a *homenaje,* a major retrospective, in Mexico. Another indication of her stature is suggested by those who wrote letters of support when she applied for a Guggenheim Fellowship in 1940, among them, art historian Meyer Schapiro, critic Walter Pach, and artists André Breton, Marcel Duchamp, and, of course Rivera.[15]

Kahlo was extremely productive in the next few years: in 1940 alone, she painted ten works. The Mexican government began to see her as a cultural resource and asked her to curate exhibitions at the Palace of Fine Arts and National Painting Fair. In 1941 she was selected to become a founding member of the Seminario de Cultura Mexicana, a group of twenty-five artists and intellectuals, who, under the auspices of the Ministry of Education, spread Mexican culture by means of lectures, exhibitions, and articles. In 1946 Kahlo was one of six artists (among them Dr. Atl and Orozco) awarded the prestigious National Prize of Arts and Sciences. Outside Mexico, too, her reputation grew, and she was included in exhibitions of Mexican art in New York, Philadelphia, Boston, San Francisco, London, Paris, and Stockholm.

Kahlo received many public and private commissions throughout this period. A particularly interesting one, which, alas, never came to fruition, was secured from the Mexican government: to paint "the five Mexican women who have most distinguished themselves in the history of Mexico."[16] Striking her usual insouciant stance, Kahlo claimed she was only doing it for the money, an attitude of indifference — both to her work and to her feminist heritage — with which she habitually armed herself. Wishing to avoid being too easily read, Kahlo sent contradictory messages to all who knew her.

It is evident from letters and reminiscences that Kahlo carefully constructed her

public persona, a presentation of self that obstructed awareness of her genuine feelings. This mask is evident in nearly every self-portrait: the viewer confronts Kahlo's immobile face, surrounded by symbols indicative of emotions and passions that she never overtly expressed. As a result, one cannot always easily reconcile the diverse, even contradictory information provided by her contemporaries in interviews.

In light of the differences of interpretations and memories, it is difficult to assess accurately Kahlo's political views or to understand fully her feminist consciousness, which she never explicitly formulated. Some friends deny Kahlo held any political principles and ascribe her activism to a desire to please Rivera. One lover, however, remembered her as "above all, a worker; a proletariat of the pencil."[17] Although Kahlo can not be claimed as a feminist in the sense the word is used today, at moments throughout her life, with certain attitudes or decisions, in opinion or actions, Kahlo demonstrates a distinct feminist awareness. Her politics were generalized but never as romanticized as Rivera's. In art and in life, Kahlo's politics emerge more subtly than Rivera's, and ultimately revolve around personal action.

To what extent Kahlo's relationships with women influenced her politics has yet to be researched adequately, but it is evident that the heterosexual bias that pervades the literature dwells upon Kahlo's marriage, childlessness, and seemingly endless trail of male lovers to the exclusion of her same-sex relationships—physical, emotional, and platonic. Throughout her life Kahlo was close to many women—nurses, confidantes, companions, friends—and enjoyed different degrees of intimacy. She also had amorous relationships with women which may be seen as a form of resistance, a defiance of established behavior and sexual roles, a disregard for propriety and bourgeois values that is visible in much of her painting.[18] Kahlo's Two Nudes in the Jungle from 1939 (plate 3), sometimes interpreted as an affirmation of Kahlo's homosexual relationships, is interesting because it is not a self-portrait but an evocation of a paradisal refuge. It is a rare image within her oeuvre, and one that warrants further attention. One wonders if, through this image, Kahlo envisioned a retreat from patriarchal Mexico and an imagined sanctuary from the vicissitudes of her relationship with Rivera.

Rivera supported Kahlo's artistic independence unconditionally. Without patronizing or condescending, he offered her sound advice about her career—from whom to get portrait commissions, who should be invited to her openings, how to handle galleries.[19] However, when he divorced her in the autumn of 1939, he disingenuously cited his concern for Kahlo's career as his motive, declaring their separation would foster Kahlo's artistic development.[20] With uncharacteristic modesty, Rivera added that he had nothing more to offer her and that he counted her "among the five or six most prominent modernist painters."[21] In spite of her

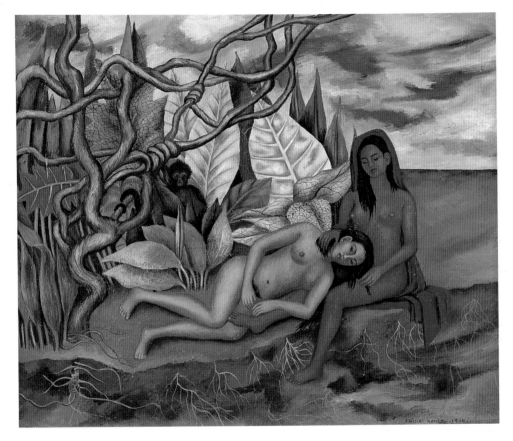

Plate 3
Two Nudes in the Jungle, 1939
Oil on sheet metal, 10 x 12 in.
Collection, Mary-Anne Martin /
Fine Art, New York, NY

distress over her divorce, which was compounded by the intrusion into her privacy by the press, and her recurring health problems (a fungal infection of her right hand and shooting spinal pain), Kahlo pursued her painting career.

Kahlo's concentration was broken suddenly in May of that year when Siqueiros made a failed attempt to assassinate Trotsky. Three months later, another effort was successful, and because of her past association with the murderer, Ramón Mercader, and Rivera's public break with Trotsky, Kahlo was suspected of collaborating. She was interrogated for twelve hours and held by the police for two days. Rivera, under suspicion since the May attempt, had left the country in the summer to accept a mural commission in San Francisco. After her ordeal with the police, Kahlo decided to join him there, in part to seek the medical advice of her friend Dr. Leo Eloesser, whom she had met during her first trip to California. Kahlo corresponded with Eloesser throughout her life, seeking his counsel on all matters of health. From California, Kahlo went on to New York with her new-found lover, Heinz Berggruen to attend to some business, but not before considering Rivera's request for reconciliation.

Kahlo remarried Rivera on December 8, 1940, his fifty-fourth "birthday." Like Kahlo, however, Rivera invented his day of birth (which was actually December 13) to coincide with the Feast of the Immaculate Conception[22] and thus dramatize his exceptional destiny. According to Rivera,

Kahlo set conditions for their reunion. She requested contractual independence, both monetary and sexual, stipulating that each would pay half the household expenses and that they refrain from sleeping together.[23] Since Rivera published this statement long after Kahlo's death, it is difficult to confirm its authenticity and is most interesting as a reflection of Rivera's memory of Kahlo's endeavor to formalize her autonomy.

Indeed, an affirmation of her new-found professionalism came when Kahlo was hired in 1943 to teach at La Esmeralda, a free art school whose prestigious staff included the outstanding artists of Mexico. Sponsored by the School of Painting and Sculpture of the Ministry of Public Education, La Esmeralda offered a five-year program that included courses in history, mathematics, French, and art history. Far from being an elitist school, the student body was mixed by gender, class, and race, and each student was provided with supplies. Classes met in an old building with an outdoor patio next to an alley from which the school took its name.[24] At first Kahlo commuted to Mexico City from Coyoacán, but the trip became too strenuous, and she held classes in her home. Eventually students dropped her class, finding the trip too long, until only four students came regularly to her house: Fanny Rabel, Guillermo Monroy, Arturo García Bustos, and Arturo Estrada, who became known as "Los Fridos" after their teacher. Los Fridos were an important part of her life and they

constituted a family for Kahlo and Rivera. This entourage of young people brought life into the home of the sixty-year-old Rivera and the failing Kahlo, whose infirmities confined her more frequently to bed. Kahlo's impact on her students was significant for the future of Mexican art. Los Fridos recall Kahlo's teaching style vividly: she was unpretentious, lacked pedantry or affectation, and yet presented an imposing, even awesome presence. She commanded respect from her students by her disarmingly direct and personal response to their work. Guided by her innate but cultivated sense of aesthetic authenticity, Kahlo's straightforward reactions engendered in her students a respect for her and for the richness and diversity of Mexican art.[25]

In spite of her erratic formal education in art, Kahlo had a remarkable eye: her taste was exquisite. She educated herself by looking, and looking intensely at everything. She visually devoured things, in museums, in the markets, in books and magazines. Her gift for discerning quality in the most unlikely places was enhanced by an exceptional ability to analyze the formal qualities of a given object. Kahlo's interest in the popular art of Mexico, in Aztec and Mayan work, in provincial painters, and in unrefined ex-voto images, took the form of acute evaluation, and she often adapted formal qualities she admired. Both she and Rivera collected Mexican art: where her husband sought out Precolumbian figures, Kahlo amassed an enormous collection of ex-votos and,

occasionally, examples of work by regional nineteenth-century painters.

In the 1940s Kahlo became absorbed in helping Rivera realize his preoccupation with building a museum. He named it Anahuacalli, meaning "the house of idols" in Nahuatl, and it was to house and display the nearly sixty thousand Precolumbian works he had collected over the years. Kahlo was passionately devoted to the project, a devotion that went beyond playing the role of helpmate to Rivera. Of Anahuacalli she says:

> This magnificent creation interlocks old and new forms . . . It grows in the incredibly beautiful landscape of the Pedregal . . . sober and elegant, ancient and perennial. It shouts, with a voice of centuries and dates, from the core of the volcanic rock: "Mexico is alive!"[26]

Kahlo's commitment to Anahuacalli speaks to her relationship to Rivera, for being married to Diego Rivera was, among other things, a matter of national pride. Rivera had succeeded in bringing Mexico into the twentieth century, placing it on the map of modern art. It may be speculated that, at the heart of a relationship that defied reason, that teemed with contradictions and cruelties (meted out by both partners), that accepted human weakness as verily as it rejected mediocrity, what bound Kahlo and Rivera was art. Despite the vicissitudes of their marriage, Kahlo and Rivera were linked by bonds that no measure of scrutiny, no attempt to corroborate and

verify myriad opinions or first-hand accounts, no psychoanalytic probe will allow the outsider fully to perceive. Their mutual affection and admiration ran deep: a passage from Kahlo's diary published in 1949 as "Portrait of Diego" gives testimony of her tremendous respect and devotion to Rivera, a narrative as revealing about Kahlo as it is about her husband.[27] Her attachment to Rivera moves beyond the mundane, to the mythical and even mystical realm. Their most enduring connection, their deepest understanding, their most thorough communication seemed to occur on an artistic level. Rivera had an immense respect for Kahlo's opinions; he stated outright that she was a better painter. He also may have envied Kahlo's ability to express emotion in art.[28] Kahlo saw Rivera as a champion of Mexicanidad, and she revered him as the embodiment of the spirit of the Revolution.

From 1944 on, Kahlo's health deteriorated. She painted nine works (mostly commissions) that year, and seven the next. After 1946, her production dropped, and she painted usually only one or two, occasionally four or five a year. In 1951 she had a productive burst and painted eight works, then only three the next year, two the next, and five the year she died. The work produced over this later period in her life is marked by a new concentration, a formidable deliberation. In content, Kahlo dwelt upon her physical condition, charting the assaults on her body, and when she could no longer bear to look in the mirror, she focused on still-life painting.

By the time she died, Kahlo had lost significant motor control, due to the large doses of pain-killing drugs and alcohol she consumed. Her last paintings lack the tight control that distinguishes her earlier work, but she continued to paint, creating in her diary, which she began in the mid–1940s, some of her most visionary and devastating images. It is in the diary, more than anywhere else, that Kahlo reveals herself. Her public self-portraits tend to mask the emotions she allows to surface in her private diary. Here her fears and passions are disclosed, in paint as well as in poetry and prose. In spite of moments of exquisite pain and grief, Kahlo's steadfast need to keep painting sustained her. The final entry in her diary demonstrates Kahlo's extraordinary ability to face the worst with singular determination and uncompromising realism:

I hope the exit is joyful — and I hope never to come back — Frida.[29]

1. Biographical facts of Kahlo's early life and her family are drawn from Herrera, *Frida:* Chapter 2; and Garcia: 1–3.

2. On Guillermo Kahlo and his career see: Gina Zabludovsky, "Has there ever been Artistic Photography in Mexico?," *Artes Visuales* 1 (Invierno 1973): 55; and Alejandro Gómez Arias, "Testimonia a Frida Kahlo," *Frida Kahlo Exposición Nacional de Homenaje,* Mexico City, 1977, reprinted in translation: *Frida Kahlo and Tina Modotti:* 38–39.

3. Anna Macías, *Against All Odds: The Feminist Movement in Mexico to 1940* (Westport, CT: Greenwood Press, Contributions in Women's Studies, Number 30, 1982): 12.

4. Tibol: 32.

5. Gómez Arias in *Frida Kahlo and Tina Modotti:* 38–39.

6. In 1946, Mexican women were granted the right to vote in municipal elections; by 1954 their rights extended to the congressional level, and only in 1958 were they granted full political rights. See Macías: 145.

7. The term "New Woman" came into currency at the turn of the century and was popularly used to describe the redefinition of the roles and status of women. A growing critical and historical literature delineates women's rapidly changing political, social, and economic position between the 1880s and the 1920s. The emergence of the modern New Woman challenged the Victorian ideal of True Womanhood, and women began to seek roles outside the domestic sphere, to call for better educational and economic opportunities, as well as to fight for suffrage.

8. Goldman: 1–2.

9. California Palace of Legion of Honor Archives, San Francisco, receipt acknowledgement of work received for Sixth Annual Exhibition of San Francisco Society of Women Artists, 1 November 1931.

10. Frida Kahlo to Nickolas Muray, 16 February 1939. Cited in Herrera, *Frida:* 236.

11. For an account of Trotsky's period in Mexico, see Jean van Heijenoort, *With Trotsky in Exile: From Prinkipo to Coyoacán* (Cambridge and London, University of Harvard Press, 1978): 104–147.

12. Frida Kahlo to Ella Wolfe, 14 February 1938. Cited in Herrera, *Frida:* 218.

13. Ibid.

14. See Dore Ashton, *The New York School: A Cultural Reckoning* (New York: Penguin Books, 1979): 91, 94–96.

15. Herrera, *Frida:* 287–288.

16. Frida Kahlo to Dr. Leo Eloesser, 18 July 1941. Cited in Herrera, *Frida:* 320–321.

17. Ignacio Aguirre, transcript by Elena Poniatowska, April 28, 1986. Courtesy of Elena Poniatowska.

18. For an insightful discussion of Kahlo's work from a critical, feminist perspective, see Borsa.

19. Diego Rivera to Frida Kahlo, 3 December 1928. Cited in Herrera, *Frida:* 238.

20. *New York Herald Tribune,* (October 20, 1939). Cited in Herrera, *Frida:* 273.

21. *El Universal,* (October 19, 1939), n.p. Cited in Herrera, *Frida:* 274.

22. *Diego Rivera: The Cubist Years.* Guest curator Ramón Favela. Organized by James K. Ballinger. (Phoenix Art Museum, 1984): 154, note 2.

23. Rivera, *My Art, My Life: An Autobiography:* 242.

24. Herrera, *Frida:* 328–29; and Porter: 62.

25. Herrera, *Frida:* 328–43.

26. Kahlo, "Portrait of Diego:" 103.

27. Ibid. *passim.*

28. Lucienne Bloch, interview by Hayden Herrera held 6 November 1978, San Francisco. Transcript courtesy of Hayden Herrera.

29. Cited in Herrera, *Frida:* 431.

THE SELF-PORTRAITS

I write because one day when
 I was an adolescent,
I looked in the mirror and no one
 was there.
Can you believe it? Complete
 nothingness.
And then, beside me "others"
assumed great importance.[1]

Rosario Castellanos

Substitute the word "paint" for "write" and Castellanos's stanza recapitulates the most striking quality of Frida Kahlo's work: she created images in which she could be sure she existed. Indeed, the fundamental theme in Kahlo's work was herself, and it

can be no coincidence that her first oil painting was a self-portrait, a bold, unabashed image in which she evokes Italian Renaissance portraiture. Kahlo represented her face in over fifty-five other works (nearly one third of her oeuvre).[2] Her earliest style, modeled on a European tradition, was modified after a few years, and Kahlo invented her own strategies by which she made visible the invisible, made real the imagined.

In her self-portraiture, Kahlo continually undertakes to situate herself at the intersection of various levels of being. In the broadest sense, Kahlo explores her condition as Mexican, as woman, and as disabled in relation to each other: these lives, these selves, compensate for each other, act as foils for one another, offer refuge. Each of Kahlo's portraits maps her tenuous hold on her self, allowing her to negotiate a way to exist, a way to position herself in the world.

At a more complex level, Kahlo's self-portraits are remarkable in that they gave visibility to events and emotions that had rarely, if ever, been represented in, much less acknowledged, as legitimate subjects for art. Her self-portraits fuse a public self with an inner, psychic self in a manner that declares the traditional mind/body separation as simply an inadequate, perhaps irrelevant, concept. If the model of Descartes' assertion *cogito, ergo sum* is understood to have influenced a modern notion of self, Kahlo's self-portraits tell us that for her, to have a body, even to have pain, is to exist.

Kahlo's extraordinary production holds a unique position in the history of self-portraiture, an art-historical genre whose own history provides a background against which to measure the meaning and relevance of Kahlo's work.[3] Artists have rendered themselves with pigment and in stone since as early as the Old Kingdom of ancient Egypt. The Western tradition continued through the Romans who were renown for their objective, unidealized portraiture, especially during the Hellenistic period. In the Middle Ages, self-portraits were generally used by artists to indicate authorship, as a signature on their work, while portraiture customarily signified the sitter's status or function, what one did in social, religious or political life. Personality only became a subject in portraiture with the dawning of the Renaissance. The credo of the period, "Man [sic] is the measure of all things," engendered the notion of individuality and personal temperament. Thus, as the ascendance of man made itself felt on the cultural fabric of the Renaissance,[4] so the portrait became a vehicle for affirming the singularity of one's own personality. Moreover, the careful attention paid to the face, a mirror to the mind, revealed the psychological dimensions of the sitter. Indeed, with the perfection of the glass mirror—a fourteenth-century Venetian invention—Renaissance artists began to portray their own faces, and a new understanding of artistic personality as depicted in self-portraiture emerged.

Modeling her *Self-Portrait Wearing a Velvet Dress* (plate 4) after Bronzino's 1540

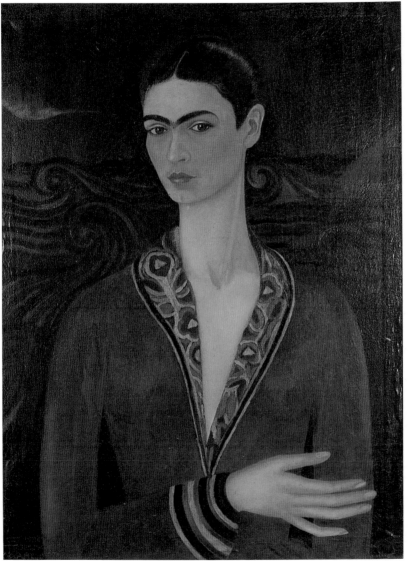

Plate 4
*Self-Portrait Wearing a
Velvet Dress*, 1926
Oil on canvas, 30¾ x 24 in.
Private collection

Mannerist portrait *Eleanor of Toledo*,[5] Kahlo not only announces her aspirations to create "high art," she also reminds us of Alberti's speculation that Narcissus, who saw his reflection in the water, was the real inventor of painting. So, too, self-portraiture was the origin of Kahlo's art. Apparent in even this first painting is Kahlo's unrelenting gaze, which she casts in a mirror, at herself, in order to render herself in paint. The intensity of her glance creates the illusion of disclosure, when, in fact, from here on, Kahlo perfects a style that allows her to hide her emotional life behind a masklike face.

There is an ambiguity in this first painting. Against the background of dark blue stylized waves and a mysterious mountain, Kahlo paints herself as regal and distanced, regarding the viewer with disdain. Or does she? On second glance Kahlo appears unsure, timid, and even vulnerable. By elongating her torso and neck, and clothing herself in a deep burgundy robe she renders herself aristocratic and aloof, but at the same time, the open velvet gown and pale skin against the red and black brocade leaves her looking hesitant and defenseless.

Kahlo's gaze rivets our attention. These conflicting interpretations of the image result from her impassive face; the masklike quality of her expression heightens the sense both of Kahlo's aloofness and of her vulnerability. In short, she expresses the polarities of her personality in this remarkable first self-portrait.

The fact of a painter's gender incontrovertibly mediates the value and meaning of the art he or she produces. A case may be made that when we do not know the author, works created within the cultural parameters of a specific age or era are seen to have similar characteristics because artists of both genders are subject to similar trends. With the disclosure of gender, other factors come into play. The instance of self-portraiture, where the fact of the painter's gender is self-evident, provides an example. The sixteenth-century Italian painter Sofonisba Anguissola, who produced more self-portraits than any artist between Dürer and Rembrandt, has been dismissed as a serious artist for spending too much time looking in a mirror.[6] In contrast, Dürer's self-portraiture is said to depict the self-contained, self-directed human being, while Rembrandt is venerated for displaying his constantly changing self-assessments in relation to God. Anguissola's oeuvre, on the other hand, has been negatively assessed due to the predetermined meanings attendant upon women looking at a mirror. Thus, so-called universal concepts such as "mankind" and "humanity" are simply not capable of being conveyed by a portrait of a woman. Instead, a woman's self-portrait becomes, by definition, personal and self-referential and has an already-given meaning: it functions as a time-honored metaphor for vanity. To paraphrase John Berger, pictures of women looking at themselves act as men's moralizing — they constitute a condemnation of women's vanity. A woman looking at a mirror treats herself first

as a sight, obliged to participate in her own objectification.[7]

As a modern genre, self-portraiture has enjoyed a mixed history. With the invention of photography in the mid-nineteenth century, artists prematurely predicted the demise of the portrait. Rather than diminish, the demand for the painted portrait flourished when it became apparent that artists could render in paint a spontaneity simply not possible with the photographic portrait which required long sessions of immobility. Painted portraiture was understood to offer, not just similitude but a window onto the personality of the sitter. Among the advanced painters of the 1870s and 80s, Gustave Courbet is an especially interesting predecessor to Kahlo. Like her, he assumes various guises, painting himself as a wandering Bohemian, a madman, a prisoner, and of course, as an artist, centrally placed in his immense canvas, *The Studio* from 1855. *The Studio* is subtitled a "real allegory," and in it Courbet, like Kahlo, depicts himself among people and things that were important to him. What disturbed viewers at the time was his use of his contemporaries, real people, in an "allegory," which presumably conveyed meanings beyond the obvious. Courbet's own words introduce the notion of an artist's right to paint whatever he or she wants: "I paint to establish my intellectual freedom . . . to express my personality and my social environment,"[8] an attitude shared by Kahlo.

After the turn-of-the-century, the artist's life and milieu itself became a subject, and van Gogh and Edvard Munch, followed by the German Expressionists, lead the way in the search for a Modernist idiom. Crudely executed woodcuts and audacious paintings of the female nude situated in the studio or frolicking in nature issued from the bohemian studios of Der Brücke. No longer cloaked in historical or mythological distance, the images of naked contemporary women (heirs to Manet's scandalous *Olympia*) implied the sexual availability of the female model, and established the myth that virility is seminal to being a Modernist. The work of the German Expressionists suggests that the female becomes part of culture only by means of the male artist's transformation of the nude into art. "Woman Modernist," therefore, seems to be an oxymoron, since the very basis of German Expressionism is the mastery of the female subject, and thus Modernism becomes defined in terms of gender.[9]

Yet, one of the precursors of the German Expressionists, Paula Modersohn-Becker, was a woman who assimilated currents of Post-Impressionism and transformed a provincial lyricism into radical simplicity and archaizing form. In contrast to the work of her male counterparts such as Ludwig Kirchner and Erich Heckel, Modersohn-Becker's nude self-portraits are startling precisely because she broached a subject few women had before confronted. Only Suzanne Valadon's pioneering self-examinations of her aging body predate Modersohn-Becker's own monumental, self-possessed

images. Both painters trespassed upon territories assumed to be a male prerogative and, in fact, their self-portraits forged a radical reconception of the relationship between women and art. The female nude, even when recognizable as a contemporary woman, endured as a "natural" subject for male Expressionists because the model remained inscribed within a relationship of unequal sexual power relations. When Modersohn-Becker and Valadon paint themselves nude, they overturn the presumed gendered relationship of artist to model. As female nudes, they are neither passive nor necessarily desirable, and thus their images are inherently unsettling.[10] Both Modersohn-Becker and Valadon created nudes that no longer fit easily into a genre whose purpose was to portray the female body for the purpose of delectation, or to reinforce relations of power, and thus both are direct predecessors of Kahlo.

Women artists who paint self-portraits have had to overcome an already-given meaning — the equation of female self-reflection with "Vanitas." They have also had to reinvent images of the self that are, nevertheless, inscribed within a patriarchal order, one which defines women first in sexual terms. Women are traditionally denied access to venues for presenting their own sense of self, and in light of these proscriptions, Kahlo's production is especially remarkable. Her construction of self is at once complex and astonishingly straightforward: without a hint of self-pity or sentimentality, Kahlo depicts her dreams, fears, passions, and pain with a forthrightness that defies social and artistic restrictions.

After completing her first painting, Kahlo painted only two independent self-portraits between 1926 and 1930, confining herself to portraits of her friends and family, among them her sisters Adriana and Christina; Ruth Quintanilla, an American married to the Mexican writer and diplomat Luis Quintanilla; Miguel N. Lira and Agustín M. Olmedo, two friends from the Preparatoria; Alicia Galant; and Lupe Marín, Rivera's second wife.

The exceptions are *The Bus* and a pair of extraordinary Cubist-inspired images on the theme of Adelita, which Kahlo painted in 1927. "Adelita" was the name of one of several Revolutionary songs popular in the 1920s that referred to a *soldadera*. The lyric is sung from the point of view of a sergeant who sings of his passion for his beloved, of his suffering heart, and of his fear of dying in battle. He entreats Adelita to bury his remains in the sierra and weep for him should he perish.[11] It was a song as much about their mutual devotion as it was about devotion to the Revolutionary future.

Kahlo situates herself in the center of *Pancho Villa and Adelita* (plate 5), the eye of a storm, wearing a shimmering, off-the-shoulder evening dress, while around her pictures seem to fall off the wall. Two male figures are sketchily painted in: one sits facing her, the other is faceless. Directly above Kahlo is a portrait of Mexico's national hero, Pancho Villa: to his left is a painted vignette from the Revolution, and

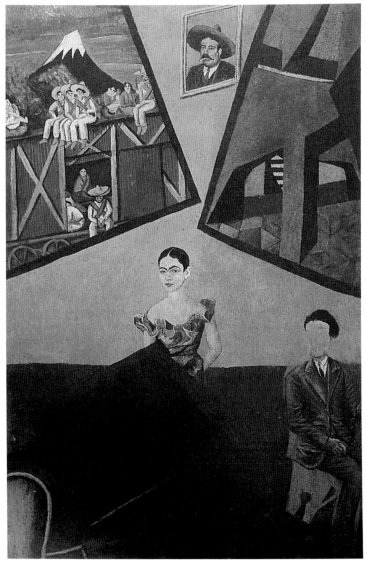

Plate 5
Pancho Villa and Adelita, 1927
Oil on canvas, 25⅛ x 17¾ in.
Collection, Instituto Tlaxcalteca
de Cultura, Tlaxcala, Mexico

to his right, a painting of a stage set or bar. In the image of the Revolution, soldiers with several *soldaderas* are placed in and on top of a freight car, which is set in front of a summary rendering of one of the two great volcanic peaks that tower above the Valley of Mexico, site of the capital, and earlier, the center of the Aztec empire.

In light of Kahlo's previous work, this painting is astonishing for its formal innovations: the fractured picture plane, the spacial disorientation, the disruption of perspectival principles, and the temporal confusion. Although its meaning remains enigmatic, Kahlo seems to suggest that one might replace mentally the faceless gentleman with Pancho Villa's portrait, as easily as Kahlo may be inserted into the background scene. The equation, although not altogether rational, seems to have Kahlo playing Adelita to her Pancho Villa. What is apparent, however irrationally presented, is Kahlo's identification with Adelita. This painting is the earliest self-portrait in which she aspires to depict a specific aspect of her identity not simply as a Mexican, but as a Mexican woman.

As Adelita's descendant, Kahlo places herself in solidarity with the *soldaderas,* primarily working-class and poor women who left their homes to be with their fighting men. These women not only suffered along with the troops but often became officers. The *soldadera,* an inherently Mexican phenomenon, was mythologized in literature and graphically depicted by printmaker José Guadalupe Posada during the Revolution and later ennobled by José Clemente Orozco.[12]

Throughout her life Kahlo sympathized with leftist issues, and participated in left-wing activism. This painting clearly indicates Kahlo's politicized consciousness, for she not only places herself in an historical relationship with Mexico's revolutionary past but adopts an appropriate foremother. Kahlo's feeling of kinship with the *soldadera* at this point in her life is a logical extension of her other activities: the same year she painted *Pancho Villa and Adelita,* she joined the Young Communist League,[13] at a time when the Communists still hoped to effect the promised reforms of the Revolution, which had so far failed to materialize. As imperialist interests were put before basic needs, criticism of government policies by labor leaders and the Communists grew more pronounced. The fact that Mexico's preeminent artists were in leadership roles in the Party may have attracted Kahlo to their ranks. As an artist, however, she resisted the Communist mandates that circumscribed formal innovation in favor of social realism.

Kahlo's small, almost miniature painting, *Self-Portrait on the Border Between Mexico and the United States* (plate 6), painted during her visit to Detroit in 1932, is a strong example of her political acumen and insight. Kahlo's perspicacious allegory of the political arrangements between these two countries places at its center a full-length self-portrait, indicating Kahlo's sense of a personal position in a larger political arena, or if you will, an early twentieth-century avowal of the politics of the personal.[14] Kahlo's figure stands at the

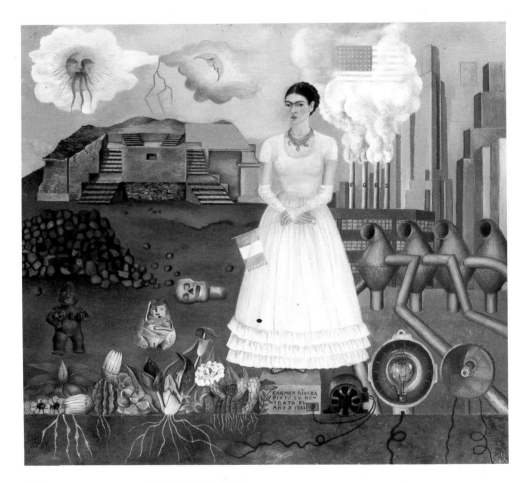

Plate 6
Self-Portrait on the Border Between Mexico and the United States, 1932
Oil on sheet metal, 12¼ x 13¾ in.

divide of two landscapes, the past on the left and the present on the right. On the Mexican land a pyramid in ruins stands in an arid landscape, while on the right, undifferentiated American skyscrapers become the modern equivalent of this ancient temple. Where the cosmic forces of the sun and moon clash to create Mexican culture on the left, the Ford factory, whose smokestacks bellow exhaust, gives forth the American flag, a cynical implication that Ford not only makes cars but also creates national identity, literally out of thin air. In the Mexican foreground, desert flora thrive and their roots (one of Kahlo's favored themes, which indicates life), extend deep into the earth. The only thing that flourishes in the sea of concrete on the right are sinister self-replicating machines that evoke Marcel Duchamp's *Passage from the Virgin to the Bride* (1912), and a trio of modern electrical appliances: a loudspeaker, a searchlight and a generator that is plugged into the pedestal upon which Kahlo places herself.

This image concretizes Kahlo's feelings of apprehension toward American imperialist policies, opinions already formulated shortly after her return to Mexico from San Francisco and expressed in a letter to a friend:

Mexico is as always, disorganized and gone to the devil, the only thing that it retains is the immense beauty of the land and of the Indians. Each day the United States' ugliness steals away a piece of it, it is a sad thing but people must eat and it can't be helped that the big fish eats the little one.[15]

The profound contrast between Mexican values and those Kahlo encountered in the United States (also addressed in *My Dress Hangs There,* done within a year of her Detroit self-portrait) served to crystalize her political attitudes.

Self-Portrait on the Border Between Mexico and the United States also reveals much about Kahlo's perceptions of her relationship with her husband, especially when read in contrast to Rivera's epic *Portrait of Detroit,* which he painted in the courtyard of the Detroit Institute of Arts, a project funded by Henry Ford. While in Detroit, Kahlo and Rivera toured the Ford Motor Company's River Rouge complex in nearby Dearborn, and other factories in the vicinity. Rivera was dazzled by Detroit, which represented to him the center of American industry and the American worker. He aspired, he said, to place "the collective hero, man-and-machine, higher than the old traditional heroes of art and legend."[16] Kahlo's opinion of Detroit was both more restrained and more critical, and in a somewhat mocking tone, she writes to a friend:

Diego is working very happily here… He is enchanted with the factories, the machines, etc., like a child with a new toy. The industrial part of Detroit is really most interesting, the rest is, as in all of the United States, ugly and stupid.[17]

Not only with words but also in her painting, Kahlo seems to be poking fun at Rivera's grandiose stance. In their art Kahlo and Rivera proceed with diametrically opposed models. He advances a grand symbolism, a macrocosm, that takes as its starting point an anonymous worker and ultimately creates an idealized vision removed from the reality of concrete experience. Kahlo, on the other hand, paints in microcosm, with herself and her personal experience standing in the field of cosmic phenomenon. In order to ground her image in the personal, Kahlo invokes a formal model drawn from popular art: a young girl's confirmation picture. Although she cloaks herself in distinctly Mexican dress and appears to be standing demurely on a pedestal, Kahlo mocks her submission by choosing to hold a cigarette in place of a fan, the required accoutrement of a lady. Thus, in a parody of the confirmation picture wherein girls offered their devotion to Christ, Kahlo seems to offer herself as a Mexican version of the New Woman.

The nearly miniature size of Kahlo's work, its private symbolic realm, in such marked contrast to Rivera's monumental, public fresco, might mitigate against comparing the two. But this is precisely where Kahlo's motive lies: she reinvents history painting as she parodies Rivera's mural. She reduces Rivera's grand symbolism into distilled opposites, thus intensifying the message.

Several months before Kahlo painted her Detroit self-portrait, she produced a double portrait of herself and Rivera in commemoration of their wedding, *Frida Kahlo and Diego Rivera* (plate 7) and in doing so constructed an image of their marriage that she simultaneously desired and resisted. On the one hand, she explicitly depicts herself playing the role of muse/wife to the genius/husband: she tilts her head hesitatingly, while Rivera holds the tools of their trade. On the other hand, Kahlo's love for Rivera in no way diminished her capacity for recognizing the limitations of this role. Kahlo counters her diffidence within the image with a stylistic paradigm that signals her move into the arena from which she establishes her stance of defiance.

In *Frida Kahlo and Diego Rivera*, Rivera looks like a large boy: Kahlo takes years off his face, shortens his pants slightly, and paints him with a sheepish look on his face. The formality of the composition allows Kahlo to distance herself from Rivera, not only by contrasting his enormous bulk to her petite presence, but also by painting in a "primitivizing" way. Here, and in other work, Kahlo uses structures of popular imagery, specifically, the space typical of the unschooled ex-voto painters. Part of the appeal of these images was their immediacy and graphic legibility. Kahlo adapted their small size to her intensely personal images and even painted on tin, as was the practice of most of these untrained artists. The field she and Rivera occupy is rudimentarily painted with little detail and only summarily suggested. To strengthen the allusion to nonmodern

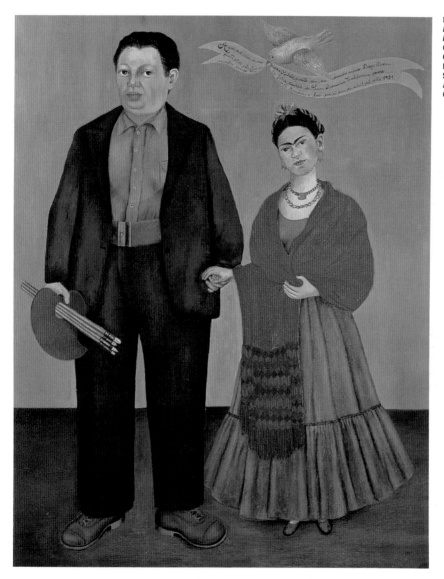

Plate 7
*Frieda and Diego
Rivera*, 1931
Oil on canvas, 39⅜ x 31 in.
Collection, San Francisco
Museum of Modern Art,
San Francisco, CA
Albert M. Bender Collection,
Gift of Albert M. Bender

art (in contrast to her self-conscious "modern" style of her Adelita paintings), Kahlo includes a pink bird bearing a message, a device used by colonial portrait painters to convey essential information about the sitters. Thus Kahlo effectively separates herself from Rivera, mapping out her own artistic terrain.

Kahlo takes a step beyond self-definition, to self-creation in a strange, even fantastic image, *My Birth,* painted in 1932 (plate 8). Kahlo does not simply depict her artistic genesis but reinvents the unknowable moment of her actual birth. It is a disturbing image on many levels: the austere setting, the utter isolation of the draped birthing woman depicted without a head, and the unusual viewpoint that results in a contorted and misshapen figure. This monstrous figure is reminiscent of the bizarre beings who populate the morality paintings of Hieronymus Bosch, as well as of marginalia in Gothic manuscripts, which also appear to have moralizing overtones, both of which appealed to Kahlo. In purely iconographic terms, however, *My Birth* is a radical adaptation of the established depiction of the goddess Tlazolteotl, who is traditionally shown in the act of childbirth. Kahlo proposes this Aztec convention (known to her through figures collected by Rivera) as a model for her imaginary image of her recent past, creating an updated, graphically present image of this Precolumbian patroness of childbirth. Years later when Rivera used the image of Tlazolteotl in his mural *History of Medicine in Mexico* in the Hospital de

la Raza, he lifts an image directly from a sixteenth-century codex because his interest was with archaeological exactitude.[18] His allusion is pat and stylized. In contrast, Kahlo transformed the appropriate Meso-American goddess, depicting herself born in the image of her Mexican past.

Kahlo set *My Birth* within the ex-voto format, an especially appropriate choice since the ex-voto customarily represents a supernatural event, which this surely is. The ex-voto mixes fact and fantasy, depicting an image of divine intervention to commemorate the miraculous recovery from a sickness or an accident (figure 2). It pictures two registers of reality: the earthly—an incident recorded with journalistic verity—and the divine—in the

Figure 2
Our Lady of Anguish
Oil on tin, 4.5 x 6 in. (unframed)
Collection, The Mexican
Museum of San Francisco
Photograph by Wolfgang Dietze

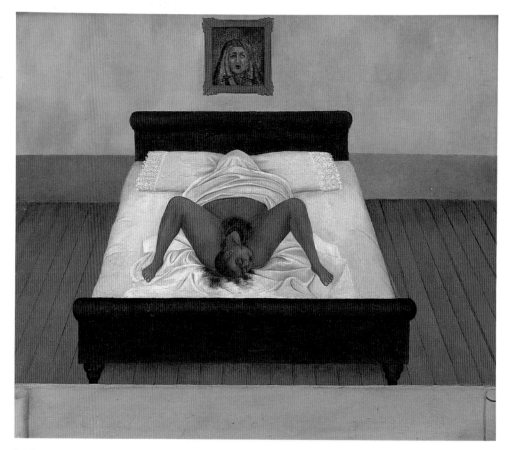

Plate 8
My Birth, 1932
Oil on sheet metal, 12 x 13¾ in.
Private collection, USA

form of a patron saint shown floating above the victim. Rivera commented astutely on the artist's conception of the ex-voto:

> . . . believing only in miracles and the reality of beings and things, he paints both of these in the retablo [ex-voto] . . . he makes miraculous events ordinary and turns everyday things into miracles.[19]

This fusion of the real and the imaginary was enormously appealing to Kahlo, and it was this aspect of the ex-voto that she appropriated for her work.

Yet while using the form of the ex-voto, Kahlo forgoes any specific Catholic sense, and, in lieu of a mystical guardian, she places on the wall in this sparse room a retablo of the Mater Dolorosa (Mother of Sorrows), another popular idiom for the expression of piety. Kahlo said that the Madonna was included not for religious reasons, but as a "memory image," because a similar retablo was present when she was born.[20] The Virgin is depicted not with her usual crown of thorns, but pierced with daggers, a peculiarly Mexican artistic innovation,[21] presiding over the bloody birth of full-grown Frida. Significantly though, this is the most important among traditional depictions of the Virgin without Christ and was invoked by believers to guard against sorrow or pain, or at the hour of death, which presents a paradox in this case.

It is likely that Kahlo identified with the Mater Dolorosa, who is often depicted shedding tears of sorrow for her lost Son. In

Figure 3
Frida Kahlo, 1930
Photograph by Imogen Cunningham with drawing and inscription by Frida Kahlo
Private collection, New York, NY
Courtesy: Carla Stellweg, Latin American and Contemporary Art, New York, NY

at least eight formal self-portraits — and in several letters where she drew caricatures of herself — Kahlo painted symbolic tears on her face. She even modified Imogen Cunningham's portrait of her by drawing tears right on the photograph (figure 3). Perhaps biography may be used to corroborate the suggested affinity, for in Kahlo's

mind, the three miscarriages/abortions she endured were literally lost children.[22] A figure from popular legend, La Llorona, the Weeping Woman, further establishes the association of tears and loss of a child, for like the Mother of Sorrows, La Llorona mourns her dead child. Thus, the tears on Kahlo's self-portraits recall her loss – she displaces her own mourning onto the Virgin. Other instances of Kahlo's conscious and unconscious use of Catholic imagery has been insightfully discussed from a psychoanalytic perspective, especially the relation of her use of heart imagery with the mystic visions of St. Teresa of Avila.[23]

The bottom of My Birth is blank, in the place of the inscription that all ex-votos bear and that usually served to concretize the event, recording the precise time, date, and players. Kahlo favored the ex-voto format throughout her career, though her secularized images never invoked a beneficent god.

A work conceptually related to My Birth is My Nurse and I (plate 9), painted in 1937. In both images, Kahlo is reinventing a formative event in her life, giving a context to her current self-knowledge. Just as she had once pictured herself as heir to the soldadera and thus the descendant of the first modern woman of Mexico, so in My Nurse and I Kahlo charts her ancestral heritage back to precolonial Mexico, depicting herself nourished by a Precolumbian wet nurse. Kahlo's strategy for establishing her heritage is similar to Michelangelo's self-mythologizing – he relates to Vasari the story of being nursed

by a stonecutter's wife in the Arezzo countryside, from whom he had "sucked in the hammer and chisels I use for my statues."[24] Both artists were indeed suckled by wet nurses,[25] and both merge this primal experience with their artistic origins and their cultural inheritance.

In My Nurse and I Kahlo's full-grown head appears in jarring disproportion to the circumstances (as it does in My Birth), signaling her centrality to the image, indeed marking her as creator of the image. The face of the nurse is painted as a stone mask from the Teotihuacán culture, while the figure was inspired by a Jalisco funerary figure of a nursing mother in Kahlo's collection (figure 4).[26] Of course, neither painting is intended as a literal representation of an event, but rather as a projection into the past that enables Kahlo to formulate a self in the present. Indeed, at one level, My Birth functions as a double self-portrait: Kahlo identifies with both figures[27] and so manages to give birth to herself, in the image and by creating it.

Both My Nurse and I and My Birth create a visual testimony to a cultural, even historical memory that Kahlo claims for herself. It is likely that Kahlo conceived them as part of a series she planned of important moments in her life, an agenda that bears a remarkable similarity to the pictorial codices that describe Aztec customs and beliefs. Following the Spanish invasion of Mexico in the early sixteenth century, the Aztec tradition of manuscript painting was co-opted by the viceregal government and was used by secular and ecclesiastical authorities alike to improve

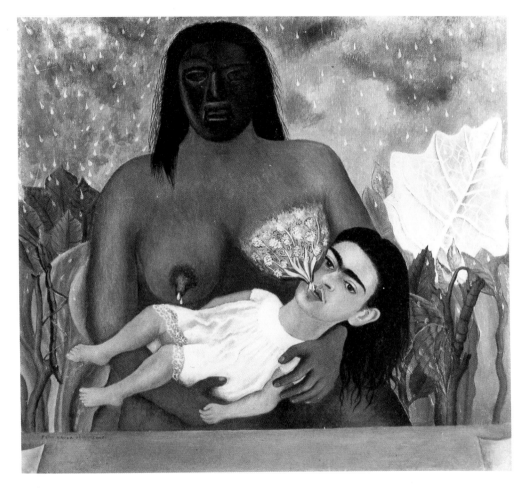

Plate 9
My Nurse and I, 1937
Oil on sheet metal, 12 x 13⅝ in.
Collection, Fundacion Dolores
Olmedo, Mexico

Figure 4
Seated female figure of
pottery, nursing infant
Height: 17¼ in.
State of Jalisco,
Mexico (300-900)
Photograph by
Carmelo Guadagno
Courtesy of Smithsonian
Institution National Museum
of the American Indian

their knowledge of, and thus strengthen their control over, the native population. The codices that survive are cultural encyclopedias or dictionaries with pictographic information, ranging from topographic data, to historical accounts of migrations, to particulars about the Aztec calendar and its feasts. The effectiveness of the codices demanded visual legibility

and detailed enumerations, usually in both Nahuatl, the Aztec language, and in Spanish. Kahlo mapped her life cycle from birth *(My Birth)* through infancy *(My Nurse and I),* in childhood *(My Grandparents, My Parents and I)* and adolescence *(Self-Portrait,* 1926), to marriage *(Frida Kahlo and Diego Rivera).* In effect, her project is analogous to the codices: charting vital information, conveying her own history, recording her experiences.

Kahlo's self-representation as Mexican implies a multileveled association: for understanding oneself as Mexican is to be inscribed in overlapping cultures. The experience of colonization, the struggle for independence, and the articulation of an artistic identity free from cultural imperialism was always at the center of Kahlo's art. Her unwillingness to be labeled forced her to confront and reclaim her heritage, to search for political, cultural, and personal identity that is the core of her life and art, as it is for many artists and writers of Latin America. It is remarkable that Kahlo, as a woman artist, marshaled the spiritual will and physical wherewithal to realize that knowing oneself was not enough: she had to reinvent herself to become herself.

An even more explicit example of Kahlo's affirmation of her Aztec descent is evident when, in the late 1930s, she adopted the Nahuatl name Xochítl, which she used as her signature on several self-portraits. Her choice is laden with connotations: *xochítl* means "flower" in Nahuatl, and thus she invokes Xochiquetzal (literally "Precious Flower"), the Aztec goddess of flowers and grain and

patroness of weavers, embroiderers, and significantly, of painters. She is also the patroness of harlots, and thus ironically, the goddess of love. Xochítl is also a day sign in the Aztec month, and those born under its sign were destined to be painters or workers in all crafts that imitate nature. Like her artist friends Geraldo Murillo, who called himself Dr. Atl after the Aztec day sign for water, and Carmen Mondragón, who changed her name to Nahui Olín, the Aztec sun god, Kahlo's choice reflects her self-invention as an artist and her identification with her Indian past.

The specific flower with which Kahlo identifies—what she calls "the flower of life" —is the blood-red blossom of the nopal cactus. For Kahlo its visual similarity to female sexual parts is its appeal. For example, in *My Grandparents, My Parents and I,* Kahlo paints it as a kind of displaced uterus, the site of her conception, which occurs in the foreground of the painting. The sexual content of *Fruit of the Earth* from 1938 (plate 33) depends upon the ripe, red fruit of the cactus flower. However, by signing her letters to her lover Nickolas Muray, "Xochítl," and from her painting *Xochítl, Flower of Life* (plate 10) done in 1938, it is apparent that she also has the flower's resemblance to a love act in mind.

It was Kahlo's custom, as friends and the press habitually noted, to dress in indigenous Mexican clothes. She favored the long dresses from the Tehuantepec region, embellishing herself with Pre-columbian earrings, necklaces, and bracelets. In part, Kahlo was motivated by a conscious disregard of appropriate bourgeois behavior, but it was equally a stance of solidarity with those classes and races that wore and produced these beautiful objects. Accordingly, in many self-portraits Kahlo wears native blouses and skirts, with special care paid to her hair, which was often rolled with brightly colored wool cords or fabrics into a headdress known as *tlacoyal.* So careful was Kahlo's attention to detail, that the origin of each outfit can be determined, thus tangibly communicating important information about her culture, as well as herself as a Mexican woman. It should be noted that Kahlo's Mexican dress, and her use of Mexican sources was not simply a matter of conforming with the current impulse of Mexicanidad and the indigenist movement; Kahlo embraced her Mexican heritage because it gave her strength. She drew upon a multiplicity of sources, constructing a polysemous self, one grounded in a native, but also female, existence.

Kahlo was attuned to the significance of specific costumes of a region, and that she used this knowledge to convey precise information is evident in her *Self-Portrait as a Tehuana* from 1943 (plate 11). Kahlo self-consciously dons the wedding dress of Tehuantepec, a region situated south of Mexico City in the state of Oaxaca. The Tehuana exists as an exception to the rule of patriarchy in Mexico: in this matriarchal society, women control the economic and political life of the people. Ideologically, Kahlo may have been prompted to identify herself as a Tehuana by Tina Modotti's well-

Plate 10
Xochitl, Flower of Life, 1938
Oil on sheet metal, 7⅛ x 3¾ in.
Private collection, R. Gomez

Plate 11
Self-Portrait as a Tehuana, 1943
Oil on masonite, 30 x 24 in.
Private collection
(opposite page)

known photographs from the late 1920s depicting the Tehuana as stately and serene, carrying baskets of laundry and produce balanced on their heads. More recently, Kahlo's friend Miguel Covarrubias published his definitive study of the indigenous culture of the Isthmus of Tehuantepec in 1946, a project he began working on in 1940 when he received a Guggenheim grant.

Other artists had painted the Tehuana in the recent past: it is likely Kahlo knew Roberto Montenegro's portrait of Rosa Rolando (later married to Miguel Covarrubias) as a Tehuana and Matias Santoyo's *Tehuana,* from images published in the progressive art magazine, *Forma.* These Modernists were attracted to the abstract qualities of the extraordinary white lace *huipil* distinctive to Tehuantepec. This rectangular-shaped dress with openings for the head and arms was worn to cover the head, in the manner that other Mexican women wore a *rebozo* (a scarf or shawl). For Montenegro and Santoyo, the potential political content inherent in the subject matter played a secondary role. Rather, the *huipil* allowed them a degree of formal experimentation. Neither are a likely visual source for Kahlo's image, which more closely resembles a colonial prototype of the *monjas coronadas* or "crowned sisters" (figure 5), a distinct aspect within the larger genre of portraiture during the viceregal period.[28] These portraits, whose origins are found in Catholic Europe, commemorated one of two events in a nun's life: her initiation into monastic life or her death. A novitiate's family commissioned a portrait before she entered the convent, which they kept as a memento. As the bride of Christ, she was lavishly crowned with flowers, a custom unknown abroad, but one which developed in Mexico as a continuation of floral headdresses integral to Aztec ritual. The nun's flowers were preserved and reused for her deathbed portrait, paid for by the convent to perpetuate her memory within the religious community.

Kahlo's *Self-Portrait as a Tehuana* shares both explicit formal and implicit conceptual elements with the *monjas coronadas.* In each, the face is surrounded by an exuberance of detail, imparting a mystical quality to the disembodied heads. The Tehuantepec wedding dress that Kahlo wears further substantiates the implied correspondence between Kahlo and the novitiate. Another point of similarity is the inclusion of a second party portrayed in a small medallion. In the *monjas coronadas,* the nuns usually hold an image that depicts either the Virgin or Christ, indicating to whom the painting is dedicated. Instead of a medallion, Kahlo paints a portrait of Rivera as a "third eye," thus dedicating the image to him. Kahlo's attachment to Rivera, as expressed most profoundly in her diary, bears comparison to the nun's mystical marriage to Christ:

> Diego is the beginning, the constructor, my baby, boyfriend, painter, my lover, "my husband," my friend, my mother, myself, and the universe.[29]

Just as Kahlo adapts the spacial and temporal organization of the ex-voto without carrying over any specific

Figure 5
José de Alcíbar (1751-1803)
Sor María Ignacia de la Sangre,
circa 1777, Oil on canvas
Instituto Nacional de Antropologia
e Historia, Mexico
Photograph courtesy of The San
Antonio Museum Association

religiosity, so she transforms the overtly Catholic image of the bride of Christ into an emblem of personal symbolism. She accomplishes this by successfully combining the Catholic prototype with a readily recognizable native costume and its attendant connotations. She thus achieves an individual mystical expression without conventional sacred significance. In short, Kahlo creates a desacralized syntax by mixing elements of Indian and Catholic art, myth, and symbolism, a syncretistic art form that in many ways reflects the basic dualistic approach to religion manifest in Mexico. Indeed, many elements of the Aztec religion were incorporated into Catholicism as it was, and still is, practiced in the New World.[30] For Kahlo, as for many Mexicans, ancient rites that survived in Indian rituals were celebrated at the same time as Catholic rites, without apparent contradiction. Kahlo simply reappropriated symbols and reorganized them into multivalent images, ultimately bereft of any theological content.

The complex, idiosyncratic imagery of Kahlo's paintings are thus not easily read nor always logically intelligible, and in the case of *Self-Portrait with Thorn Necklace and Hummingbird* (plate 12) painted in 1940, the many layers of association create an intricate series of meanings. Native symbols and imported Catholic symbols converge in this painting, and they interact to create a truly syncretic image. On the most obvious level, the necklace of thorns alludes to Christ's passion, symbolism Kahlo has drawn from her Catholic upbringing. As a portrait, it also evokes the

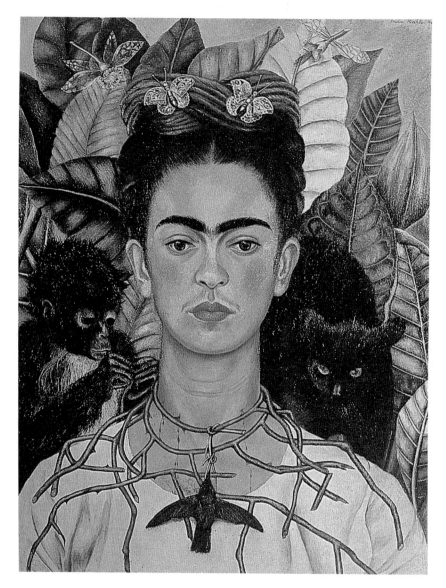

Plate 12
*Self-Portrait with
Thorn Necklace and
Hummingbird*, 1940
Oil on canvas,
24½ x 17¾ in.
Collection, Harry Ransom
Humanties Research
Center, University of
Texas at Austin

miracle of St. Veronica, who, after wiping the Savior's brow, found His image with the crown of thorns mysteriously transferred onto her veil. Moreover, Veronica (from "vera icon") herself is associated with the surcease from flowing blood. In addition to Christian allusions, Kahlo draws from her Mexican heritage, making reference to Aztec tradition of divinatory rituals entailing self-mortification with maguey thorns.[31] The dead hummingbird around her neck and the butterflies in her hair are Aztec symbols that signify the souls of dead warriors.[32]

The absolute frontality of this pose, unusual for Kahlo, and the utter lack of depth transform the image into a secular icon. The monkey, an omnipresent pet, which makes its appearance in eight self-portraits, functions like a religious attribute and further underscores the iconic quality of the image. Kahlo may also be referring to the Aztec conception of a *nahual*, or animal alter ego. The ancient Mexicans believed their gods had the capacity to transform themselves into animals at will.[33] Kahlo often depicts herself with her pets, including dogs and parrots, an allusion to this belief. The cat, on the other hand, seems to be a more generalized symbol of death, imparting an ominous sense of doom.

Iconographic analysis of Kahlo's paintings cannot "explain" their meaning. But sorting out the various connotations indicates the level of Kahlo's sophisticated and discriminate choices and suggests how her self-portraits are significant at many levels of meaning. Kahlo never represented a single self but always a multicultural one. By mingling symbols from a diverse body of beliefs, she manages to reveal relations between things known and unknown.

On this occasion Kahlo brought together diverse cultural references in a self-portrait; at other times she was unable to achieve this fusion. The other-worldly quality of Kahlo's 1939 image, *The Two Fridas* (plate 13) can be understood as pictorial manifestations of contradictory self-images. The two Fridas cannot logically (either physically or emotionally) share the same space. Kahlo establishes two images of herself, divided and yet allied, contrasting but nevertheless corresponding to the same body. Virtually all Kahlo's self-portraits navigate her ego among political, social, and emotional structures: she conceives of herself as Mexican, female, and physically damaged. Her portraits are plastic evidence of her will to contextualize herself—they are testimony to her search for existential meaning in a world of doubt. For Kahlo, neither ego nor personality define her: it is the indisputable existence of her body, transmitted from mirror to canvas, that brings her closest to being.

Against a cloudy sky painted in a manner reminiscent of her treatment of the *pedregal,* Kahlo seats the two Fridas on a rustic, caned bench in a nondescript space. Rivera referred to this style as "occult materialism,"[34] and the fact that the two Fridas also share a circulatory system

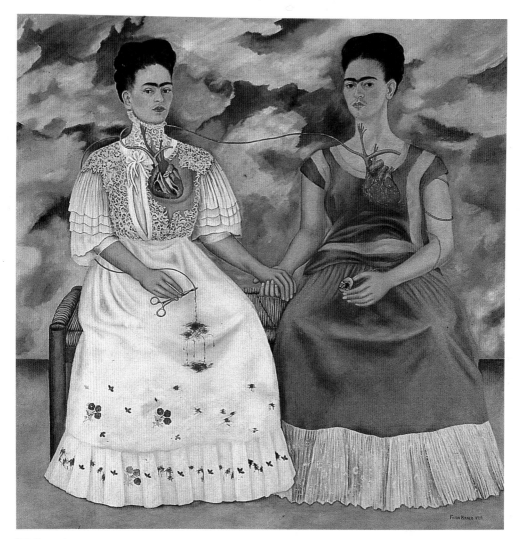

Plate 13
The Two Fridas, 1939
Oil on canvas, 68⅜ x 68½ in.
Collection, Instituto Nacional de
Bellas Artes, Museo de Arte
Moderno, Mexico

may account for his assessment. The mystical association is further implied since the Frida on the right holds a small emblem of Rivera, like the emblems associated with the *monjas coronadas*. Kahlo depicts the two Fridas separated by a generation, differentiated by their clothing: on the left she is dressed in traditional Victorian dress, and on the right she wears a Tehuana skirt and blouse. In an interview at the time the image was finished, Kahlo is said to have remarked on the identities of the two Fridas: one was the self that Rivera once loved and the other, the one he no longer loved.[35] This cryptic, and ultimately unsatisfactory explanation, one that, indeed, transcends a biographical reading alluding to her divorce, indicates Kahlo's unfailing acknowledgment of the mutability of social meanings. For what the two Fridas share, significantly, is a symbiotic physiological existence — their bodies remain immutable and constant, while their costumes shift their meanings in the cultural realm of signification. Kahlo is not merely expressing aspects of her personality but constructing alternative selves, creating her own personae. This image is not a self-analysis but a self-invention. While acknowledging that she is subject to prescriptive patriarchal power structures beyond her control, Kahlo works from her own self-knowledge to create other possibilities for her selves.

Kahlo also explores the social construct of "woman" in *Self-Portrait with Cropped Hair* from 1940 (plate 14). She puts forth not an analysis of her own identity, but an exegesis of the cultural definition of femininity. For what Kahlo eliminates from her self-image are the social trappings of womanhood: long hair, dresses, and even modest posture. In light of the proscription against cross-dressing that dates at least to biblical scripture [Deuteronomy 22:5], and in light of the claim of social-anthropologists that clothing not only grants, but produces social meaning, this image of transgression is astoundingly daring. Wearing an oversized man's suit, holding a pair of scissors where a "lady" would hold a fan, looking directly at the viewer, Kahlo challenges the viewer to see her as a woman. Ever conscious of the meaning of costume, Kahlo's deliberate refusal to acquiesce to conventional modes of dress signals her declaration of independence. By adapting the trappings of authority, she readily acknowledges the power such a masquerade confers. Kahlo's images invert traditional expectations and thus question the viability of constructing a female self using male-created forms of expression. The lines from a popular song painted above the figure of Kahlo point out how women's status relies upon elements of social signification (clothing, conduct, physical beauty), and how resistance to prescribed modes of behavior is rewarded with, in this case, emotional disenfranchisement.

> Look, if I loved you, it was for
> your hair,
> Now that you're bald, I no longer
> love you.

Plate 14
Self-Portrait with Cropped Hair, 1940
Oil on canvas, 15¾ x 11 in.
Collection, The Museum of
Modern Art, New York, NY
Gift of Edgar Kaufmann, Jr.

The animation of Kahlo's sheared tresses, as they twist and slither around her, as if energized by their new-found freedom, inevitably recall the roots and veins that appear with regularity in Kahlo's work. She often painted tendrils, roots, nerves, vines, imagery derived, in part, from her physiological knowledge: veins carry blood, and roots bring nourishment just as nerves transmit pain. Where in other cases, for example *Self-Portrait on the Border Between Mexico and the United States* (plate 6), *The Dream* (plate 27), *Self-Portrait as a Tehuana, Two Nudes in the Jungle* (plate 3), and *Roots,* roots signify a groundedness, an interconnection with all life, here, severed from their origin, the tendrils of hair are rendered incapable of providing stability or nurture. Nothing grounds the figure except Kahlo's unyielding gaze with which she engages the viewer.

The immobile face characteristic of *Self-Portrait with Cropped Hair,* and almost every self-portrait, reads as a mask, an interpretation Kahlo not only acknowledged but courted. Her calculated effort to disguise her emotions and hide her feelings while she relentlessly depicts her life on canvas produces an ever-present tension in her images. On the one hand, Kahlo delivers astonishingly personal portraits while, on the other, she intentionally withholds vital information. Her omission is self-conscious and internalized: indeed, she refers to herself as "la gran ocultadora," a not-easily translatable phrase, since, like Kahlo's aesthetic, it is synthetic.

Perhaps "the great unrevealed one" gets at the sense of her deliberately-sought ambiguity.

Kahlo's *The Mask* (plate 15) painted in 1945, addresses forthrightly the issues around identity and exposure and is a particularly arresting image for a painter who focused so intensely on her own face. At first glance, Kahlo seems to be seeking respite from her own intense gaze, from introspection, and from self-construction by taking on another's view. Yet Kahlo was remarkably able to deny herself as art object. Nowhere does she present her body according to the traditional notions of the female body in art. She is, both to herself and to her viewer, the object of the gaze. Kahlo manages to participate in and then protest against the social construction of herself as woman. It is the mask that allows her to call attention to this construction, as it allows her an "other" personality.

In contrast to the many images of Kahlo that obscure her personality, *Self-Portrait with Loose Hair* from 1947 (plate 16) is one of her most disarmingly candid images. Kahlo forgoes all accessories, omitting her pets and elaborate headdresses, and includes only a modest succulent growing from the rocky *pedregal* of the background. *Self-Portrait with Loose Hair* is reminiscent of her first self-portrait (plate 4): they share understatement and constraint less evident in most of the others. Both act as a kind of reckoning, the earlier coming to terms with her new life, the later coming to terms with who she is at age forty, in an arrestingly direct way.

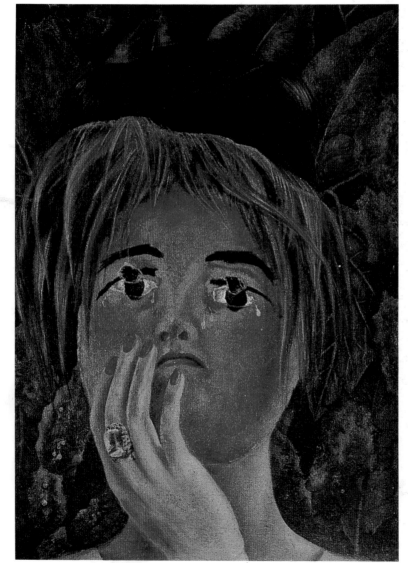

Plate 15
The Mask, 1945
Oil on canvas, 15¾ x 12 in.
Collection, Fundacion Dolores
Olmedo, Mexico

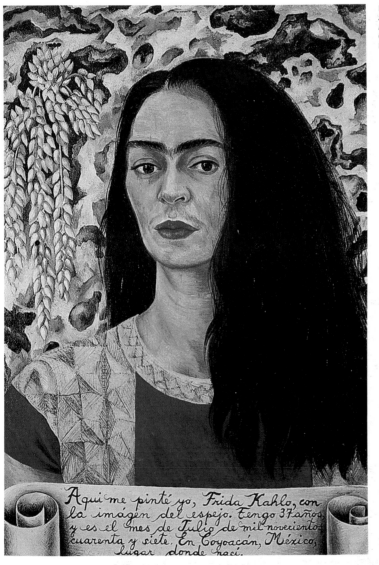

Aqui me pinté yo, Frida Kahlo, con la imágen del espejo. Tengo 37 años y es el mes de Julio de mil novecientos cuarenta y siete. En Coyoacán, México, lugar donde nací.

Plate 16
Self-Portrait with Loose Hair, 1947
Oil on masonite, 24 x 17¾ in.
Private collection

It is worth pausing to remember that, although Kahlo has become mythologized, her life sensationalized, her paintings now worth millions of dollars, her celebrity and global reputation is rather recent. She is thought of as an outstanding woman artist, prevailing over significant impediments, and it is tempting to assign her the status of genius since her life story suggests that, like the myth of the "great artist," her genius enabled her to navigate or overcome obstacles.[36] Yet her life parallels the lives of those few women who managed to have artistic careers before the nineteenth century who were either daughters of artists or married to artists: Kahlo was both.[37]

Consider, too, how Kahlo presented herself to the world as an artist. Only once did she depict herself with her palette (see *Self-Portrait with a Portrait of Dr. Farill,* plate 18). In letters she often was self-deprecating about her artistic merits, mocking those who were interested in her work, and presenting herself as merely a siphon. In a popular, public forum, her "selling point" was her naiveté: Bertram Wolfe quotes her in *Vogue* as saying: "The only thing I know is that I paint because I need to, and I paint always whatever passes through my head, without any other consideration."[38]

In contrast, when she applied for the 1940 Guggenheim Foundation Fellowship, Kahlo presented herself as a more complex painter, although she claimed indifference to visual precedents and motifs:

For twelve years my work consisted of eliminating everything that did not come from the internal lyrical motives that impelled me to paint. Since my subjects have always been my sensations, my states of mind and the profound reactions that life has been producing in me, I have frequently objectified all this in figures of myself, which were the most sincere and real thing that I could do in order to express what I felt inside and outside of myself.[39]

Kahlo acknowledges that her images are the result of her reactions and not simply "without consideration," and yet this "self-portrait" was disclosed to only a restricted few.

Art historians often take Kahlo's stance of innocence at face value, suggesting that she captured reality and transmitted this to her paintings without mediation. In spite of her use of popular motifs, and her self-deprecation aside, Kahlo was keenly aware of the magnitude of difference between her work and her sources. She took umbrage when Breton included Mexican folk art he bought in the markets of Mexico in her Paris show, referring to them as *"all this junk."* Due in large measure to her nearly single-minded attention to herself, Kahlo has been described as being "obsessed with the truth," — and this in spite of the fact that she often depicts herself dressed up in other people's clothes, masked to hide her emotions, or placed in fantasy scenarios. What appears to be

"truth" is certainly deeply personal for Kahlo, but it is a truth that manages to reveal as much about herself as it does about her culture. It was Kahlo's unwillingness to compromise, her inability to conceal her passions, and her courage in facing tragedy and suffering that is mistakenly called "truth." Coupled with the subject of her work and her realism, this has led some to conjecture that Kahlo simply transcribed her life into a series of gut-wrenching images, without artistic intervention. This, plus the autobiographical aspects of her work, have given rise to psychoanalytic readings of Kahlo's production, which tend to highlight the therapeutic while eliding the inherent artistic sources.

Many of Kahlo's works can indeed be seen as a restorative working-out of the conflicts that assailed her mind and spirit. At one level, many of Kahlo's images that deal directly with bodily insults are references to her accident. Yet she never made an ex-voto of that event, perhaps because it was too traumatic to picture. Other than touching up an ex-voto previously dedicated to another vehicular collision,[40] the only overt reference she made to the accident was a 1929 painting called *The Bus,* showing an array of Mexicans from various social and economic classes seated together in a row. The bus signifies a place where all Mexicans meet and where anything might happen — opportunities as well as unanticipated disasters.

The pain and suffering so conspicuous

in Kahlo's later work lead some to interpret her paintings as unmediated illustrations of biographic events. Her paintings that are admittedly grounded in actual incidents are diminished without the broader significance that a careful visual interpretation can provide. *Henry Ford Hospital* (plate 17), depicting her anguished, indeed, life-threatening miscarriage in 1932, is an image that marks the beginning of the style and content Kahlo would develop over the next twenty years. It brings together formal constructions based on Mexican traditions, as well as what can be called a Modernist vision of the body in the brave new world.

Much has been made of Kahlo's longing for a child: her prophetic adolescent declaration that she would have Diego Rivera's child is invariably cited as the beginning of this subject. Her bloody images of her many ill-advised pregnancies and subsequent agonizing miscarriages or therapeutic abortions work in concert with other images — of germination, of birth, of nurturing, and even of Rivera cradled in her arms — to convey a lifelong despair at barrenness. But in the context of Mexican social codes, where having a child, indeed, where motherhood itself, not only was an indispensible aspect of femininity but virtually defined womanhood, Kahlo's desperation is readily understandable. Without suffrage, women in Mexico had no officially sanctioned political life and were thus confined to a domestic role. The public and private dichotomy maintained a strict separation

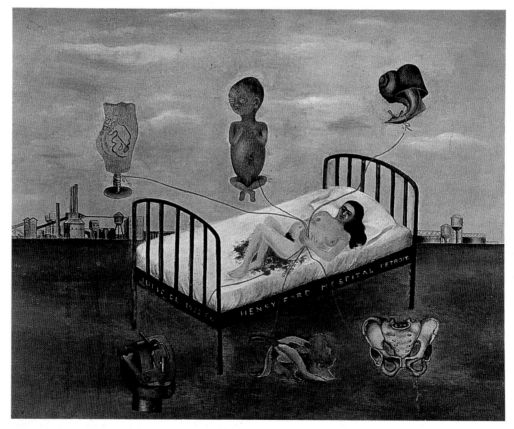

Plate 17
Henry Ford Hospital, 1932
Oil on sheet metal, 12 x 15 in.
Collection, Fundacion Dolores
Olmedo, Mexico

between the genders, and yet Kahlo's imagery manages to shatter the laws of patriarchy. Her painting moves into an alternative space, not simply critical of the status quo but maneuvering itself beyond it, charting other avenues of possibilities.

The image that most vividly marks the beginning Kahlo's journey into alternative visions is *Henry Ford Hospital,* painted at the time Rivera was working on his murals for the Detroit Institute of Arts. It is a stunning work, not only for its entirely original imagery, but for the way Kahlo assembles objects that for her symbolize the bewildering emotions and sensations of her month-long ordeal of miscarriage. Six objects circle Kahlo, each tied to her with a red veinlike ribbon. In the center is the fetus she lost, an excruciatingly accurate portrait of her miscarried child. To his left, Kahlo paints a medical model, science's idea of what is inside a woman, an image of what she lacks. Diagonally across, on the lower right-hand side, is a rendering of her own pelvis, the guilty party: her broken bones, a result of her accident, which prevent her from carrying her baby to term and are damaged further by sexual intercourse.[41]

These objects pose little confusion in this context and seem logical inclusions. However, the other three items are mystifying, and without Kahlo's own words, they would be difficult to interpret. The snail, at first a seemingly whimsical choice, in fact embodies for Kahlo the *experience* of an abortion, which was slow, and in her words, "soft, covered and at the same time, open." This extraordinary transformation of

a horrifying experience into a tangible and, significantly, animal form is paradigmatic of the nature of Kahlo's symbolism. Feelings, sensations are converted into concrete objects, which stand in for deeply felt interior processes. The bruise-colored orchid at the bottom center of the painting, a flower given her by Diego, was included, according to Kahlo, to mix a sexual metaphor with the sentimental. The last object is a machine whose function is unknown. Kahlo had an understandable aversion to machines: it was, after all, a machine that caused her injury in 1925. Her abhorrence is made utterly clear in her *Self-Portrait on the Border Between Mexico and the United States* (plate 6) where she contrasts the diverse fruit of Mexico's earth and history with the mechanical reproduction of homogeneous automatons and proliferation of monolithic, uniform skyscrapers. She said that she invented the image of the machine in *Henry Ford Hospital* "to explain the mechanical part of the whole business" — presumably, the operation and the hospital, and even Gringolandia. Kahlo was surely aware of the irony that, while she lay in a hospital bed at the mercy of the tools of modern medical science, Rivera was busy painting a homage to the age of the machine.

In this image, as in others, Kahlo presents herself in an entirely uncharted space, both literally and figuratively. The bird's-eye view of Kahlo naked in a hospital bed, which floats in an unarticulated space in front of the Detroit skyline, underscores the no-man's-land in which she finds

herself. The painting is original in conception and in construction, for Kahlo has radically reformulated the space of the ex-voto. The miraculous scene of the ex-voto, which traditionally takes place in a nonspecific indoor space, is here modernized, as is the miracle to which the votive painting refers. Kahlo pays a tribute, however ambivalent, to the miracle of modern medicine. She paints herself literally as the object of the gaze, but not simply a male gaze,[42] but specifically a medical gaze, eyed and controlled by science. Like her predecessors Modersohn-Becker and Valadon when Kahlo paints herself without clothing, she eschews the traditional role of object of desire.

In 1951, just three years before her death, Kahlo painted *Self-Portrait with a Portrait of Dr. Farill* (plate 18) in which she offers a quite different, and more sympathetic response to modern medicine. Formally, it is one of the most modest and restrained of Kahlo's self-portraits, and yet its simplicity is deceptive. Among her self-portraits, it is unique in that it is the only time she represents herself as an artist. Yet, significantly, Kahlo substitutes a heart for her palette of colors: her paint brushes seem to drip blood. The heart, neither idealized nor romanticized, is presented as corporeal and real, an ironic comment on the supposed content of women's "inner life," which consists not of spirit but bodily organs, an insight that is evident in a number of Kahlo's paintings.[43] Images of visceral hearts and excesses of blood recur throughout Kahlo's work, and both are central images in Aztec ritual and culture. Kahlo has expressed the notion of self-sacrifice and blood-letting associated with Precolumbian heart symbolism, and it prompts one to ponder what it cost Kahlo to produce art. Nearing the end of her life, and having spent almost a year in the hospital after perilous spinal surgery, Kahlo pictorially confronts the existential problem of the relationship between art and life. Kahlo's blood is synonymous with paint, and her heart is the source of her imagery, but it also functions as an offering to Dr. Farill. Kahlo is perhaps convinced that modern medicine may supplant old-fashioned miracles.

Two works done within a year of her death are remarkable in conveying Kahlo's indomitable spirit, her extraordinary ability to transform debilitating experiences into revelatory imagery. At the time her right leg was amputated, Kahlo created an image in her diary of two severed feet on a dias, with the legend, "Feet, what do I need them for, if I have wings to fly" (plate 19). The image is devastating in its utter resistance to defeat. Kahlo demonstrates her acceptance of the transitoriness of life yet insists on her unyielding passion to live. Her legs, amputated at the knee, look like *milagros,* literally miracles (figure 6), small silver reproductions of parts of the body that are worn around the neck or hung near the saint to whom the recipient of the miracle owes thanks.[44] It is Kahlo's ironic humor that enables her to present her feet as *milagros* in the absence of any miracle.

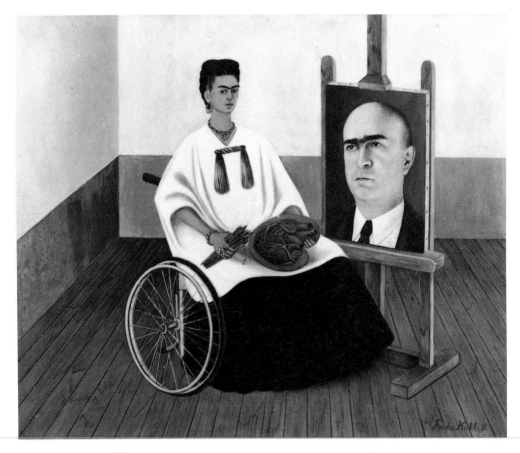

Plate 18
*Self-Portrait with a Portrait
of Dr. Farill*, 1951
Oil on masonite, 16⅜ x 19¾ in.
Private collection

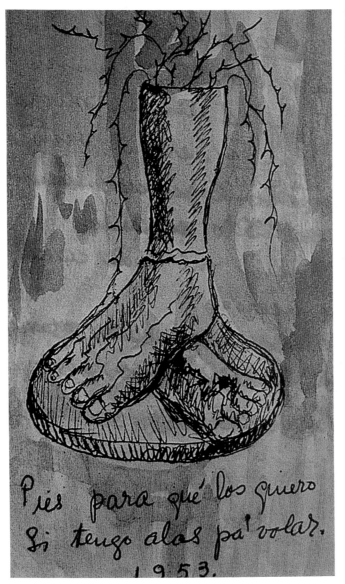

Pies para qué los quiero
Si tengo alas pa' volar.
1953.

Plate 19
*Feet, what do I need them for,
if I have wings to fly,* 1953
Ink
Frida Kahlo's diary
Collection, Museo de Frida
Kahlo, Mexico

Figure 6
Milagros
Photograph by E.E. Smith,
Brooklyn, NY

Marxism Will Heal the Sick from 1954 (plate 20) gives testimony to Kahlo's belief late in life in an order beyond herself. The painting stands in contrast to much of her previous work, in which she posited the individual experience as the only way to know reality, to acknowledge being. Now her trust in medicine had run its course, and her faith in the future lay in a Marxist utopia. If this image indicates a certain

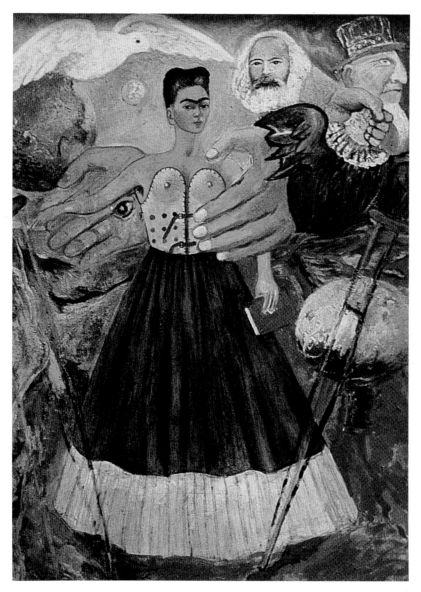

Plate 20
*Marxism Will Heal
the Sick*, 1954
Oil on masonite, 30 x 24 in.
Collection, Museo de Frida
Kahlo, Mexico

political naiveté, it also attests to Kahlo's need at this late date to believe in a truth greater than herself. *Marxism Will Heal the Sick* functions as a political ex-voto—but rather than giving thanks for divine intercession for her personal benefit, Kahlo acknowledges a more powerful spirit beyond herself, a spirit that might deliver relief to all who suffer.

1. *Another Way to Be: Selected Works of Rosario Castellanos.* Edited and translated by Myralyn F. Allgood. (Athens, GA and London: University of Georgia Press, 1990): XXXI.

2. This estimate is derived from examining *Frida Kahlo: Das Gesamtwerk.*

3. See Ludwig Goldscheider, *Five Hundred Self-Portraits from Antique Times to the Present Day, in Sculpture, Painting, Drawing and Engraving* (Vienna: Phaidon Press, 1937); and Edward Lucie-Smith and Sean Kelly, *The Self-Portrait: A Modern View* (London: Sarema Press, 1987).

4. See Joan Kelly-Gadol's ground breaking essay, "Did Women have a Renaissance?" reprinted in Renate Bridenthal, Claudia Koonz and Susan Staurd, eds. *Becoming Visible: Women in European History.* 2nd ed. (Boston: Houghton Mifflin Company, 1987): 175–201.

5. Teresa del Conde, cited in *Frida Kahlo: Das Gesamtwerk*: 84; and Herrera, *Frida:* 110.

6. *Women Artists: 1550–1950.* Organized by Ann Sutherland Harris and Linda Nochlin. Exhibition catalogue. Los Angeles County Museum of Art. (New York: Alfred A. Knopf, 1981): 27.

7. John Berger, *Ways of Seeing* (New York: Penguin Books, 1972): Chapter 3, especially 50–51.

8. Cited in Alan Bowness, *"The Painter's Studio,"* in Petra ten-Doesschate Chu, ed. *Courbet in Perspective* (Englewood Cliffs, New Jersey: Prentice-Hall, Inc., 1977): 138.

9. See Alessandra Comini, "Gender or Genius? The Women Artists of German Expressionism": 271–291 and Carol Duncan, "Virility and Domination in Early Twentieth-Century Vanguard Painting,": 292–313, in Norma Broude and Mary D. Garrard, eds. *Feminism and Art History: Questioning the Litany* (New York: Harper & Row, 1982).

10. See Rosemary Betterton, "How do women look? The female nude in the work of Suzanne Valadon," reprinted in Rosemary Betterton, ed. *Looking On: Images of Femininity in the Visual Arts and Media* (London and New York: Pandora, Routledge & Kegan Paul, Inc, 1987): 217–234.

11. Toor: 310, 411–12.

12. See Macías, *Against All Odds*: 40 ff.

13. García: 14.

14. See Terry Smith's two articles in *Block.*

15. Frida Kahlo to Dr. Leo Eloesser, 14 June 1931. Cited in Herrera, *Frida*: 127.

16. Rivera, *My Art, My Life: An Autobiography*: 183.

17. Frida Kahlo to Dr. Leo Eloesser, 26 May 1932. Cited in Herrera, *Frida*: 134–135.

18. *Diego Rivera: A Retrospective* (Detroit: Founders Society of the Detroit Institute of Arts, 1986): 323.

19. Cited in Fondo Editorial de la Plastica Mexicana. *The Ephemeral and the Eternal of Mexican Folk Art.* vol. 2 (Mexico: 1971): 528.

20. Frida Kahlo, interview with Parker Lesley, Mexico City, 27 May 1939. Transcription courtesy of Hayden Herrera.

21. Giffords: 47.

22. Tibol: 50.

23. See Salomón Grimberg's article, "Frida Kahlo's *Memory.*"

24. *Giorgio Vasari, Artists of the Renaissance: A Selection from "Lives of the Artists,"* translated by George Bull. (New York: Viking Press, 1978): 234.

25. Frida Kahlo, interview with Parker Lesley, Mexico City, 27 May 1939. Transcription courtesy of Hayden Herrera.

26. *Frida Kahlo.* Organized and essay by Salomón Grimberg: 66, note 6.

27. Frida Kahlo, interview with Parker Lesley, Mexico City, 27 May 1939. Transcription courtesy of Hayden Herrera.

28. See Pernoud's insightful essay "Une autobiograhie mystique: La peinture de Frida Kahlo."

29. Cited in Herrera, *Frida*: 379.

30. See Lafaye, *Quetzalcóatl and Guadalupe.*

31. Elizabeth Hill Boone, "Painted Manuscripts," *Mexico: Splendors of Thirty Centuries* (New York: Metropolitan Museum of Art, 1990): 272.

32. Toor: 459 and 461.

33. Durán: 68, note.

34. Rivera, "Frida Kahlo y Arte Mexicano," in *Frida Kahlo and Tina Modotti*: 37.

35. MacKinley Helm, *Modern Mexican Painters* (New York: Harper & Brothers, Publishers, 1941): 167–168.

36. Linda Nochiin, "Why have there been no great women artists?" in Thomas B. Hess and Elizabeth C. Baker, eds. *Art and Sexual Politics* (New York: Macmillan Publishing Co., Inc., Collier Books, 1973): 1–43.

37. *Women Artists: 1550–1950*: 41.

38. Wolfe: 64.

39. Cited in Herrera, *Frida*: 288.

40. Illustrated in *Frida Kahlo: Das Gesamtwerk*: 228.

41. All quotations referring to *Henry Ford Hospital* are taken from Frida Kahlo, interviewed by Parker Lesley, Mexico City, 27 May 1939. Transcription courtesy of Hayden Herrera.

42. See Chapter One, "Is the gaze male?" in E. Ann Kaplan, *Women & Film: Both Sides of the Camera* (New York and London: Methuen, 1983): 23–35.

43. Franco: 107.

44. Toor: 70.

Surrealism, "Primitivism," and the Still-Life Tradition

I never painted dreams. I painted my own reality.[1]

Frida Kahlo

Most accounts of Frida Kahlo's painting take her preoccupation with self as an invitation to search her biography for a key to the meaning of her work. The excessive attention paid to the dramatic circumstances of her life obscures the art-historical circumstances of Kahlo's production and results in her virtual exclusion from art history. But her work can be seen apart from her biography, and important artistic sources that place her within the art-historical activities of the 1930s and 40s can be identified, independent of the details of her life.

Kahlo's work may be placed within two art practices of the early twentieth century: first, the Latin American art that aligned itself with the revolutionary left, which was then engaged in nationalist programs. This movement relied upon the figural tradition to impart meaning and has yet to be satisfactorily understood in an international context. Second is the Surrealist movement, Kahlo's connection to which is still difficult to determine. She did share sources, some formal conventions, and at times, even subject matter with the French Surrealists who gathered around André Breton. Yet Kahlo's work must be seen as originating within an explicitly Mexican tradition, and thus she may be viewed as a distinctive, equivocal member of a difficult-to-define movement.

The artistic intelligentsia in Mexico of the 1920s was conversant in European Modernism, even if it chose not to embrace it wholly. The Mexican vanguard, which included notable expatriates from France, Germany, Spain, and the United States, formulated a Modernism tailored to the conditions of their social, political, and historical circumstances in Mexico. Mexico's first vanguard art movement consisted of artists and poets who loosely joined together and called themselves the Movimiento Estridentista, translated roughly as the "Strident Ones." Manuel Maples Arce's 1921 Estridentista manifesto, published in *Revista Actual,* was modeled on, and indeed invoked the earlier Italian Futurist and Dada proclamations. Like the Europeans, the Estridentistas rejected outmoded thought and praised the modern beauty of the machine in the most shrill and aesthetically offensive language possible. The manifesto concludes with a "Directory of the Avant-Garde," a list of over two hundred artists (very few of whom are women) of diverse nationalities, including members of the Dada group, as well as artists who soon would become Surrealists.[2] The Estridentistas shared with their European counterparts a contempt for conventional aesthetic formulations. Significantly, however, the crucial distinguishing factor is their renunciation of all art and poetry divorced from the Mexican scene. The value placed on modern Mexican life, "Mexicanidad" as it was called, coincided with a growing interest in the indigenous art of Mexico and increasing sense of nationalism, characteristics evident in contemporary vanguard movements in other Latin American countries.[3]

From this initial Modernist phase arose the celebrated mural movement during the post-Revolutionary reconstruction that took place in Mexico in the mid-1920s. Attendant upon the socialist movements that swept the globe was a backlash against nonobjectivity as artists relied on descriptive realism to express their social concerns. At first energized by the promise of widespread social reforms, Rivera, Siqueiros, Orozco, Charlot, Xavier Guerrero, and Máximo Pacheco, among others, advanced a principle of a socially meaningful art, using the figurative tradition to convey a didactic message. They

eschewed social realism in favor of a "figurative Modernism," turning to Mexican sources for their aesthetic.[4] The emergence of a realist style in Latin America coincides with manifestations of figurative art around the world, most notably Neue Sachlichkeit, or the "New Objectivity," in Weimar Germany, which represents a parallel rejection of abstraction and is exemplified in the work of George Grosz and Otto Dix. In the United States during the 1930s, the practice of social-realist painting was seen as a viable alternative to pure abstraction by artists with such divergent politics as Grant Wood and Ben Shahn. Drawing on Mexican sources then, the muralists proceeded to reconstruct Mexican history through visual means, embodying the political aspects of Mexicanidad.

Kahlo also roundly rejected European modernist abstraction in favor of the figural, but she also rejected the instructive aspect of the muralists, along with their public position. But like the Estridentistas and the muralists, Kahlo focused her attention on Mexican reality. What marks her work as especially innovative in a climate of Modernism was her remarkable ability to take motifs, themes, and even styles from within Mexican culture and reinvest them with new meanings. Thus Kahlo developed a position that accommodated her own interests but that bore a relationship to the Mexican avant-garde, combining elements of modernist aesthetic with a social awareness of her Mexican heritage.

Was Kahlo a Surrealist? She is often held to be one,[5] despite the many aspects of her work that make such a definition questionable. Some have indeed argued against such a designation, insisting that Kahlo drew too heavily upon her own experience.[6] One important difference between Kahlo and the French artists is that many of her formal innovations sprang not from intellectual constructs but from traditions in Mexican art: the odd spacial quality of the ex-votos, the mixing of human and animal forms often seen in Aztec imagery, and themes that to European eyes might have seemed morbid but that were common in colonial art. One answer to the vexing question may lie in how we define Surrealism. If we are to believe Breton, who saw Kahlo's painting as "pure surreality" and, in fact, sought to bring her into the club, then Kahlo may indeed be counted among its ranks. On the other hand, to place her neatly within this category is to ignore the complexity of her sources and motives. Thus, perhaps we should recast the question, asking instead: What are the surreal elements in Kahlo's work? What are her sources? To what extent is Kahlo indebted to European Surrealism?

The definition of Surrealism is complicated by the ever-changing cast of characters associated with it. Breton's tyrannical desire to dominate this circle, the factional fighting, vacillating alliances, and recurrent expulsions among the Surrealists make it difficult to assign any single meaning. The initial group was dominated by the painters Max Ernst, André Masson, and Joan Miró,

and thus the 1924 Manifesto of Surrealism reflects their reliance upon automatism, accident, and biomorphism as means of expression—all elements that are, by and large, absent from Kahlo's idiom. On the other hand, the impetus for using these methods, to "express the functioning of the mind,"[7] is, in fact, close to the way Kahlo's paintings function. The Second Manifesto of Surrealism (issued as an article in 1929 and as a book the next year) reveals the influence of the imagists such as Salvador Dali and René Magritte, with whose realist style Kahlo had more in common. The spacial qualities evident in much of Kahlo's work is similar to the "landscapes of the mind" devised by Surrealists Yves Tanguy and Dali.

Kahlo marshaled a variety of formal strategies in order to convey her personal symbology, and these coincide with Surrealist means of expression. Additionally, Kahlo had a high regard for the work of Henri Rousseau and Giorgio de Chirico, whom the Surrealists cited among their progenitors. Thus it is not surprising that when Breton arrived in Mexico in the spring of 1938, he felt Kahlo's work embodied the tenets of Surrealism. But Kahlo's work was equally informed by stylistic conventions of her Mexican past. However, her recognition that these forms were viable for a modern artist may indeed have been informed by Surrealist notions.

Kahlo herself was ambivalent about being called a Surrealist and never fully identified herself with the movement. When interviewed in 1938, she claimed, with a degree of insincere deference, "I didn't know I was a Surrealist till André Breton came to Mexico and told me I was."[8] Breton's trip to Mexico earlier that year had a two-fold purpose: under the auspices of the French Ministry of Foreign Affairs, he was obliged to present lectures on French culture. His private agenda, however, involved drawing artists into the Surrealist fold. At the time of his visit in 1938, his international movement was stagnating and was no longer considered the cutting edge of the avant-garde—indeed, that very year Jean Charlot, a French artist transplanted to Mexico, declared Surrealism "a thing of the past"[9]—and so Breton was seeking support in other countries and arenas.

Breton's interest in Precolumbian art (by the late thirties he had accumulated a sizable collection) fueled his desire to visit Mexico. But the interest of the European Surrealists in non-Western art, which they imprecisely called "primitive,"[10] is at odds with Kahlo's own undertaking. Where Kahlo's appropriation of native art traditions stems from a restitution and revaluing of Precolumbian art in the context of her own culture, the Europeans' "ethnographic"[11] interest in Africa, Oceania, and to some extent, Meso-America provided "other" religions and forms that enabled them to revitalize their work. Kahlo's incorporation of the formal and symbolic aspects of Aztec art may be seen within the context of Mexicanidad and understood as a search for her own indigenous history. Indeed, Kahlo's effort may be profitably compared

with those of the Blaue Reiter (Gabriel Münter, Wassily Kandinsky, and Alexej Jawlensky). Their interest during the first decade of the century in the Bavarian popular tradition of painting on glass was prompted by both nationalistic and aesthetic motivations. Similarly, Adolph Gottlieb was working with imagery derived from Navajo sand painting in the early 1940s, after abandoning American-scene subject matter in favor of the colors and forms derived from Native American petroglyphs and totems.

The place Mexico occupied in the Surrealist imagination was stimulated not only by Breton's familiarity with Precolumbian art but no doubt also by the account his Surrealist comrade Antonin Artaud made after he had visited Mexico two years earlier. As if not to be outdone by Artaud (expelled from the Surrealist group by Breton in 1926), who "discovered" the work of María Izquierdo, Breton made Kahlo his Mexican trophy. It is perhaps no coincidence that Breton and Artaud each returned to France with a female souvenir. Since they were predisposed to see Mexico as an exotic, distant, and mythic "other" place, only a woman artist could fully embody the "otherness" that Mexico signified. The fact that both Kahlo and Izquierdo incorporated Precolumbian sources in their work made them even more ideal representations of Mexican Surrealism.

Breton's eulogistic, if somewhat self-serving, preface to Kahlo's 1938 exhibition at the Julien Levy Gallery in New York — in which he collapses the idea of woman and Mexico — makes clear his sexualized construction of both Kahlo and her country. After declaring that her paintings had blossomed into "pure surreality," Breton then asserts that Kahlo had "no prior knowledge of the ideas motivating the activities of my friends and myself"[12] with a patronizing and provincial arrogance. His presumption that Kahlo arrived at her formal resolutions intuitively has the effect of dismissing her conscious artistic decisions, while perpetuating his self-proclaimed power to confer value on art that was otherwise inconsequential. Breton concludes:

> I would like to add now that there is no art more exclusively feminine, in the sense that, in order to be as seductive as possible, it is only too willing to play alternately at being absolutely pure and absolutely pernicious.[13]

In this striking display of reductive essentialism, Breton sexualizes both Kahlo and her work so that her art becomes merely a reflection of a masculine idea of the feminine.

Despite Breton's faulty view that Mexico was insulated from European Modernism, Kahlo was keenly aware of Surrealism at this time, whether or not she identified herself as a Surrealist. Kahlo had been exposed to Modernist trends at least as early as 1926 and was, at any rate, familiar with Arce's "Directory of the Avant-Garde," which concluded the Estridentista

manifesto. Among the artists specifically mentioned were Max Ernst, Tristan Tzara, Marcel Duchamp, George Ribemont-Dessaignes, Philippe Soupault, Francisco Picabia, Paul Eluard, and André Breton himself.[14] The fact that Rivera—who had returned to Mexico from Paris six months prior to the publication of the manifesto—was also on the list suggests that he was a key player, a conduit between the European avant-garde and the most progressive artists of Mexico City.

Kahlo's first canvas that displays proto-surrealist elements, however, is her remarkable *Portrait of Luther Burbank* (plate 21) painted in 1931 when she and Rivera were living in California. In addition to French Surrealist imagery, which she had known previously, one wonders if she came into contact with Surrealism as it had been interpreted by the Californians Helen Lundeberg and Lorser Feitelson.[15] Rivera was at work on his *Allegory of California* mural for the San Francisco Stock Exchange, a commission that, according to dogmatic Communists, placed him irretrievably in the capitalist camp. Nevertheless, drawing upon his own flexible brand of Marxist ideology, Rivera justified his commission by choosing to dramatize the interdependence between capital and California's natural resources, both mineral and vegetal. Rivera included a portrait of Luther Burbank, who developed new varieties of plants in his acres of nurseries during his fifty-year

career in California. It is likely that Kahlo—who had never met Burbank—felt challenged to show the man and his work as somehow merged. Eschewing any political content, Kahlo ingeniously combines differing levels of knowing and being, multiple moments of growth and decay within a cosmic framework of life and death. She paints Burbank metamorphosed, part human, part plant, in a sense, analogous to his own development of new forms of life.

Kahlo's interest in transmutation was reignited as she read about Burbank's work on hybrids, and her solution for integrating his life's work into his posthumous portrait is an example of her inventive synthesis. As a young girl, Kahlo was enchanted by the story of Paolo Uccello's life in Marcel Schwob's *Imaginary Lives*,[16] where he is likened to an alchemist as he throws geometric

> forms into a crucible, mix[es] them, mingle[s] them and melt[s] them, striving to transmute them into one ideal form containing all.[17]

It is probable that Kahlo read more extensively about alchemical processes—perhaps she even saw Breton's 1929 Manifesto in which he points to the analogy between Surrealism and the Renaissance alchemists.[18] Kahlo's formal interests and pictorial experiments are structurally similar to three basic tenets of alchemy. First, the idea of mutation and transformation as a metaphor appealed to her, as is evident in many of her paintings: her *Portrait of Luther*

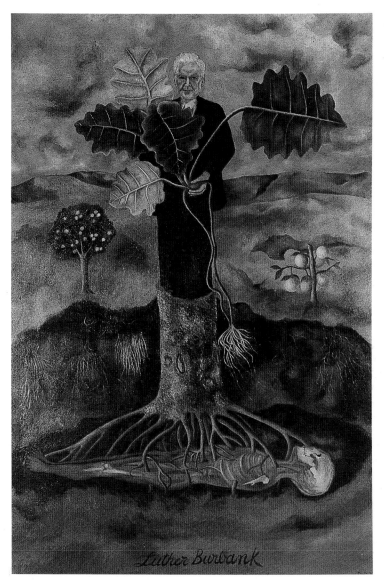

Plate 21
Portrait of Luther Burbank, 1931
Oil on masonite, 34 x 24¼ in.
Collection, Fundacion Dolores
Olmedo, Mexico

Burbank, The Wounded Deer (plate 30), and even *Xochítl: Flower of Life* (plate 10) — in which she depicts plant life mimicking human sexual intercourse — are among the most obvious. A second and more subtle operation of alchemy that appears in Kahlo's painting involves combining opposite properties, usually allegorical male and female principles. The hermaphrodite, which embodies both sexes, is evident in two strange, nearly identical portraits Kahlo painted of herself and Rivera in 1944 to commemorate their fifteenth wedding anniversary. In a single portrait Kahlo paints a face divided down the middle, the left side is her self-portrait and the right half is Rivera.

Color symbolism also plays a crucial role in alchemy, and in her diary/sketchbook, begun in the forties, Kahlo listed the colors of her palette and what they signified to her.[19]

> REDDISH PURPLE: Aztec. Tlapali
> [meaning color in Nahuatl]
> Old blood of prickly pear.
> The most alive and oldest.
> BROWN: color of mole [a rich sauce
> made from chiles and chocolate],
> of the leaf that goes. Earth.
> YELLOW: madness, sickness, fear.
> Part of the sun and of joy.

Kahlo's colors derive their significance directly from her specific locality, from indigenous meanings and their relevance to native customs and culture. The immediacy and empirical pertinence of Kahlo's chromatic record contrasts with, for example, the universalizing, mystical meanings Wassily Kandinsky assigned to color. Kahlo's use of various color combinations in her painting tends to induce moods and provoke atmosphere, and she uses color to evoke the scents, contrasts, and chromatic tones of Mexico, rather than to provide literal or precise meanings.

Kahlo's *Portrait of Luther Burbank* marks the beginning of a more complex view of reality, a vision marked by her interest in life cycles, in the simultaneous depiction of the internal and external, in dualities inherent in cosmic orders, which derive, in part, from her Mexican heritage. The Meso-American artists were not content with reproducing what was visible to them. A likeness of a tree was not complete unless the roots were shown,[20] a conception intrinsic to her image of Burbank. That Kahlo's method of dealing with imagery has structural similarities to the Precolumbian art from her native land suggests that she was well acquainted with their artistic conventions, a conjecture supported by the vast collection of ancient Mexican art she and Rivera assembled and displayed in their home (figure 7). Kahlo's conceptual approach to art was not lost on Breton, who wrote in his accolade to her:

> I had long been impatient to go [to Mexico], to put to the test the idea I had formulated of a kind of art which our own era demanded, an art that would deliberately sacrifice the external model to the internal model, that would resolutely give perception precedent over representation.[21]

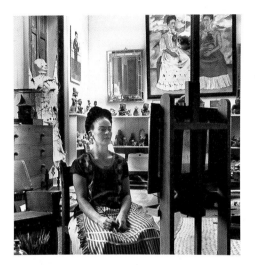

Figure 7
Frida Kahlo, Xochimilco, 1937
© Fritz Henle / Photo
Researchers

The Surrealist preoccupation with ethnography brings up another point of dissimilarity between Kahlo and the Surrealists. Kahlo's use of subjects and formal elements that derive from Mexico's past constitute her adaptation of her own artistic heritage. For Breton, "primitive" art offered the experience of the aesthetically unfamiliar, an intellectual challenge; it represented for him the Other and had a significantly different meaning for him than it had for Kahlo, whose culture was permeated by the "primitive." Until 1937, the only Surrealist elements that appeared at all in Kahlo's work were manifest in *Portrait of Luther Burbank*. Her primary sources continued to be popular and folk

painting of Mexico, evident in her double portrait *Frida Kahlo and Diego Rivera* (plate 7), also from 1931, based on the pictorial conventions of the ex-voto.

Kahlo's work is incontrovertibly grounded in her identity as a Mexican and the Surrealist elements in her painting stem from her own cultural background. In his review of her exhibit at the Levy Gallery, Walter Pach acknowledged these Mexican sources of her surrealism.[22] In a short piece published the year Kahlo died, artist and curator Susana Gamboa accounts for Kahlo's imagery by specifically citing the long history of Mexican art. She wrote that in treatment Kahlo's painting

> is imaginative and phantastic, but the mood is poetic, full of age old Mexican symbolism which has less to do with Frida as an individual than with Mexico as an aesthetic heritage.[23]

A Few Small Nips (plate 22) painted in 1935, offers another instance of Kahlo's application of popular art. It is among her most disturbing images and derives its subject matter, in part, from imagery popularized by Guadalupe Posada. Posada's lurid prints of gruesome murders and ghastly accidents were, in fact, visual recaps of recent events, created for the illiterate, and sold for pennies on the street (figure 8). Several of the post-Revolutionary artists—Dr. Atl, Jean Charlot, and Rivera, among them—"discovered" Posada. In their minds, Posada's illustrations for broadsides and *corridos* formed a crucial link between a folk tradition and the

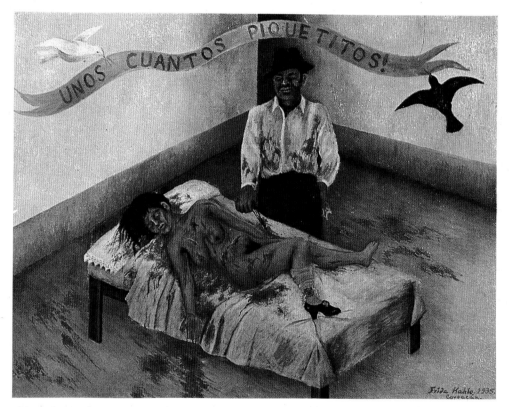

Plate 22
A Few Small Nips, 1935
Oil on sheet metal, 11⅝ x 15½ in.
Collection, Fundacion Dolores
Olmedo, Mexico

Figure 8
José Guadalupe Posada
(1852-1913)
Francisco Guerrero, alias El
Chalequero (the vest maker),
slitter of women's throats.
1887 victim, murdered at
the Rio Consulado.
1890 broadside, type metal
engraving

Mexican Modernist practice by providing the muralists with a model of an art that was inherently Mexican.[24] Posada based his work upon popular art but cast off European aesthetics, and thus represented the earliest recent instance of an alternative artistic tradition.

Kahlo's attraction to Posada lay also in his macabre humor and shocking explicitness, similar in timbre to *A Few Small Nips,* which, in turn was inspired by a newspaper story of a brutal murder of a woman by her drunken husband. In keeping with Kahlo's sardonic sense of humor, the title derives from the killer's answer upon being charged with murder: "But I only gave her a few small nips."[25] This understatement

contrasts with the exaggerated depiction of blood, which splashes out onto the frame of the painting, literally into the viewer's space. While Posada is one source, such excess derives in part from the graphic realism and directness of polychromatic sculpted images of Christ's passion found throughout Mexico's churches. Based on Baroque models, the Mexican versions' realistic colors and explicitness render the wounds of Christ vividly and literally. For Kahlo, however, the mark of blood is woman's mark: she depicts women riddled with puncture wounds, bleeding after an abortion or childbirth, spilling blood from a vein connected to her heart, or pierced with arrows. However, the excess use of blood removes this image from the traditional symbolism associated with women, beyond the two diametrically opposed connotations that link women and blood. Usually blood is identified as the "curse" of menses, a taboo, signifying filth and pollution, defilement and degradation. On the other hand, the blood shed on the wedding night certifies virginity, signals purity, and thus confers value upon the bride.[26] For Kahlo, blood is not symbolic, it is real — it is present in the everyday life of Mexico.

A Few Small Nips is not simply an indictment against violence inflicted upon women. Kahlo painted this image shortly after* arriving back from her stay in the United States. One wonders if, in part, the painting is a reaction to the shock of being back in Mexico after having to endure the "disgusting puritanism" and "endless

pretension" of the dull, bland gringos. Kahlo preferred, in her words, the Mexican "thieves," "hijos de la chingada" (sons of bitches), and the "cabrones" (bastards) to the infuriating colorlessness of the North Americans.[27] Violence as a part of life in Mexico was something Kahlo had experienced her entire life: "in Mexico killing is quite satisfactory and natural" she said of this image.[28] It was an inextricable part of her culture upon which she reports rather than editorializes. Kahlo paints not the action of violence, but its aftermath, its consequences.

A Few Small Nips is remarkable also for the way Kahlo deftly overturns the established expectations of the female nude. The gritty reality of the scene, utterly lacking in any erotic overtones, undermines the conventional presentation of woman's body in art. Additionally, Kahlo's presentation of the convergence of sex and violence contrasts sharply with the manner in which Surrealism treats the subject. Women's sexuality, as constructed by that male coterie, was decisively influenced by their reading of the Marquis de Sade, whose pornographic writing both affirmed and perpetuated the association of violence with female sexuality. Their idea of woman was structured on male fantasies. Indeed, although women played a central role in the conception of French Surrealist ideology, they were relegated to the role of muse, the passive mediator between nature and creative man.[29] The elaborate Surrealist constructions of the feminine are wholly inventive, whereas for Kahlo being

a woman was not imaginary. Unlike Surrealist art, which glamorized misogyny and in whose visual images women are portrayed with a stylized, sanitized elegance, Kahlo's painting serves as an explicit reminder of the concrete reality of daily violence in women's lives. Where the Surrealists fantasized about the hidden mysteries of "la femme," Kahlo often exposes the internal, literally. The Surrealists endeavored to evoke, visually or verbally, extraordinary realities drawn from the erotic, the exotic, and the unconscious: for Kahlo, extraordinary realities were her present.

The Deceased Dimas, 1937 (plate 23), like *A Few Small Nips,* was painted in response to a specific experience. Its hyper-realist and phantasmagorical appearance is deceptive, at first seeming to be a Surrealist invention, but as she did in *A Few Small Nips,* Kahlo draws upon an already existing visual model, in this case, a tradition of mortuary portraits that dates to the colonial period. Additionally, Kahlo's conception is based upon the traditional Mexican funeral rites. In Mexico, children's wakes are cause for celebration, based on the Catholic belief that they die free from sin and therefore go straight to heaven. Custom dictates that the child's corpse be laid out in costumes similar to those worn by their patron saint. Dimas was Rivera's godson, a young member of an Indian family who often posed for Rivera. He died unnecessarily, as many children did, for lack of adequate medical care.[30] The gladiolus that Dimas holds refers to the

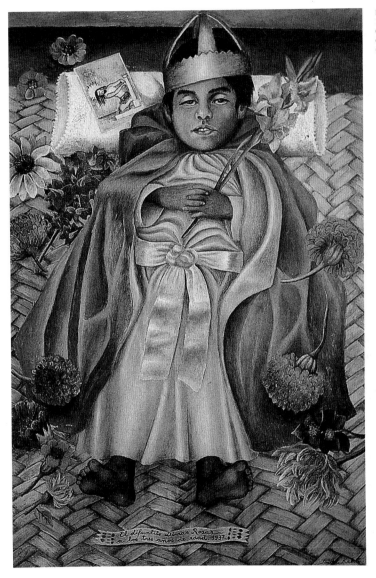

El difuntito Dimas Rosas
a los tres años de edad. 1937.

Plate 23
The Deceased Dimas, 1937
Oil on masonite, 19 x 12½ in.
Collection, Fundacion Dolores
Olmedo, Mexico

budding staff belonging to St. Joseph. The dancing and music that accompanies the funeral of the *angelitos* (little angels, as the dead children were commonly referred to) are for their amusement. It is believed that the purity of the *angelitos* gives them the power to intercede on behalf of the living.[31]

The imagery of the *angelitos* developed during the viceregal period, when the well-to-do would commission portraits of their dead children laid out amid elaborate floral arrangements. With the invention of photography, mortuary portraits became more widely available, and photographic images of *angelitos* flourished.[32] But *The Deceased Dimas* was not a commissioned painting: in spite of the lace pillow and velvet cape, the bare feet of this small Indian child and the petate mat made of reed upon which he lies belie that possibility. The *angelito* as a subject interested Kahlo as it had her contemporaries Siqueiros, Izquierdo, and Juan Soriano. But for her it was a personal response to a child's life cut short. The small touches Kahlo adds make the image both an intimate response and an embodiment of the macabre: his half-closed eyes, the trickle of blood running down his mouth, and a postcard depicting the flagellation of Christ all contribute to the child's unearthly appearance.

In fact, *The Deceased Dimas* imitates the stylistic conventions evident in the work of Mexican nineteenth-century provincial painters—such as José Maria Estrada, José Augustín Arrieta, and Hermenegildo Bustos—whom Kahlo admired. Eschewing traditional perspective in favor of the precise transcription of detail in order to provide similitude, they nevertheless worked within the genres typical of the colonial period, earning their living from commissioned genre scenes, portraiture, retablos, and still-life paintings.[33] By emulating the style of the popular artists, Kahlo achieves an eerie realism: Dimas's presence is a bit too vivid. Kahlo's interest in popular art led Luis Cardoza y Aragón to categorize her, along with Fernando Castillo and Máximo Pacheco, as a "primitive."[34] Indeed, Kahlo's use of forms of expression that derive from untrained art production places her firmly in the twentieth-century tradition of so-called Modern Primitives, a concept articulated in the 1938 exhibition at New York's Museum of Modern Art, Masters of Popular Painting: Modern Primitives of Europe and America. The curators intended the show "to present some major divisions or movements of Modern Art,"[35] and Masters of Popular Painting was, in fact, the third, after the monumental Cubism and Abstract Art (1936) and Fantastic Art, Dada, Surrealism (1937).

The exhibition was a consequence of Henri Rousseau's "apotheosis," which generated an interest in divergent modes of Modernist expression. Kahlo is often compared with Rousseau and, like him, is presented as sui generis. Both are called "primitive" because neither subscribed to the use of linear perspective or illusionist lighting, although their styles derive from

different sources. Rousseau's is attributed to his interest in the fourteenth-century Italian and Flemish primitives while Kahlo's issues from colonial art of Mexico. Like Kahlo and Rousseau, the artists represented in the Museum of Modern Art's 1938 exhibition eschewed pictorial illusionism and had heretofore been mistaken for amateurs. To label them "Modern Primitives" enabled the curators to distinguish them as individuals—rather than anonymous amateurs—working in the context of the Western tradition, even if they chose not to depend upon academic practice. It also distinguished these artists and their production from other modes of "primitive" art.

The term "primitivism" has many connotations and is subject to misunderstanding.[36] But two meanings of primitive may be discerned. The first, a manifestation of a Euro-centric point of view, fed by a colonialist heritage, indicates a culture or artistic tradition outside the Western purview, especially art from tribal Africa, Oceania, and Precolumbian America. A second meaning identifies the art produced in folk and popular traditions within Western cultures. Practitioners of these two modes tend to be thought of as anonymous, while the term "Modern Primitive" assumes an individual artist.

In addition to Kahlo's adaptation of certain "primitive" qualities inherent to colonial art, she also turned to objects that may be characterized as *arte popular,* denoting art made by the peasantry, often by indigenous cultures, and thus carrying meanings that the imprecise translation "folk art" lacks. Such sources provided Kahlo with references to non-European cultural products, forms authentically Mexican. In *Four Inhabitants of Mexico City* (plate 24) painted in 1938, as in other work, Kahlo mixes forms of popular expression with Modernist forms. She depicts herself as a child looking extremely small, gazing up at three giant figures: a cardboard-and-reed Judas effigy wrapped with fire crackers, a pregnant Tarascan clay statue, and a skeleton, or *calavera.* Behind this group is a smaller figure, a children's toy horse and rider made of reeds. When this canvas (then titled *The Square Is Theirs*) was exhibited at the Levy Gallery in 1938, the "art" value of these figures was readily apparent to Walter Pach. In his review he explicitly pointed out to his New York readers that these popular figures—as used by Kahlo—are works of art, and "are rightly to be called modern."[37]

The "modern" quality of the figures in *Four Inhabitants of Mexico City* is enhanced by Kahlo's approach to space, which she adapted from the proto-Surrealist Giorgio de Chirico.[38] The extraordinary expanse of the Mexican plaza where the figures are situated, the long shadows cast by each character, and the overall sense of alienation recall the nostalgia that pervades de Chirico's "metaphysical" piazzas. Both artists painted vast "landscapes of the mind" within which they placed players outside time. The difference is that Kahlo is not denouncing modernism so much as she is celebrating her culture. Where de Chirico

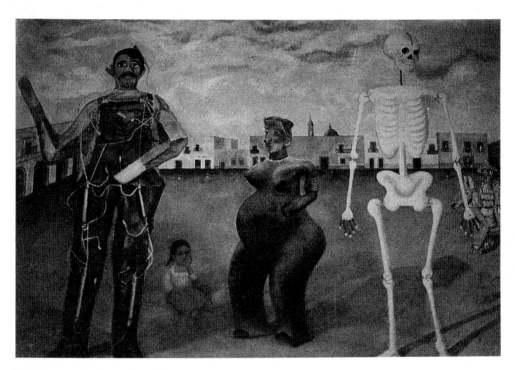

Plate 24
Four Inhabitants of Mexico City
(The Square is Theirs), 1938
Oil on sheet metal, 12¾ x 18¾ in.
Private collection, California

longs for an idealized past, spurning the present in favor of an imaginary past, Kahlo updates and modernizes her figures in a way that recognizes their history while at the same time affirming their relevance to the present.

Still, there is a bittersweet quality to this image. Kahlo's explanation is, as usual, paradoxical.[39] Each of these four "inhabitants of Mexico" carries specific meanings and traditions, which, taken as a group, are representative of aspects of Mexican life that Kahlo celebrates. The *calavera,* she says, is death: "very gay, a joke." He stands grinning, in a modified contrapposto, irreverent despite the gravity of his symbolism. Opposite the *calavera* is a Judas figure wrapped in firecrackers. The custom of burning effigies of Judas Iscariot — sometimes depicted as a policeman or, during the nineteenth century, particularly contemptible members of the ruling aristocracy, on the Saturday of Glory (Holy Saturday) — originated in Spain. The paper dummies were encircled with fireworks and incinerated, providing entertainment as well as a constructive way to vent a collective class frustration and anger.[40] Judas appears several times in Kahlo's work, notably in her monumental *The Wounded Table* from 1939, which was exhibited in the 1940 Surrealism show in Mexico; and he figures as a skeleton in *The Dream* (plate 27). She said of the Judas figure that it was a pretext for joy, gaiety, and irresponsibility.

The central idol of *Four Inhabitants,* a Tarascan clay statue, is overtly pregnant and acts as a metaphor for the nature of the Indian as Kahlo understood it: inert outside, moving and living inside. Luis Cardoza y Aragón summarized this notion effectively: "Nothing is farther from inertia and quiet than the mediative [Indian]."[41] The stillness that pervades *The Square Is Theirs* is not de Chirico's nostalgia, but rather a quiet acceptance of Mexico's "culture of death."[42] For even as a representation of fecundity, the rounded idol offers not only a reminder of Mexico's fertile artistic past, but a poignant reference to Kahlo's barrenness, as the little girl watches these inhabitants of Mexico parade by her, steeped in the presence of death.

Throughout 1937 and 1938, when Kahlo began producing work with more regularity than she had before, she began working with elements in her painting that might be called "Surrealist." Kahlo's most convincingly Surrealist image, and the one that Breton used to illustrate his *Surrealism and Painting,* is her 1938 *What the Water Gave Me* (plate 25). Nowhere is Kahlo's imagination more completely uninhibited nor scale less relevant, nowhere does illogic reign more blatantly, nor do the imaginary and the real mingle more vividly than in this image. Kahlo's "dream" floats upon a medium that reminded Breton of a phrase spoken by his clairvoyant lover, Nadja: "I am the thought of bathing [literally, "I am the thought on the bath"] in a mirrorless room."[43] Kahlo presents forms with double meanings: a cluster of black, viney growth mimics pubic hair; the conch symbolizes, as it has traditionally, labia;

Plate 25
*What the Water
Gave Me*, 1938
Oil on canvas,
34⅝ x 27⅛ in.
Isidore Ducasse
Fine Arts

even the volcano echoes the ulcer on her foot. Such resemblances recall Breton's urging for "the free and unlimited play of analogies" as a means of expression.[44] Another striking aspect within the image, one that concurs with Surrealist practice is the systematic displacement of objects from their familiar surroundings in order to achieve astonishing, sometimes disturbing juxtapositions. By rendering various realities simultaneously, unrelated images and objects drift past each other, and their proximity conveys emotions that are inarticulable: they become visual evidence of the ineffable and invisible. Across the image Kahlo scatters sets of oppositions: her healthy foot is contrasted with her deformed foot, shown bleeding from a trophic ulcer. A man-made skyscraper emerges like a tumescent phallus from within the crater of an erupting volcano whose lava has razed more than one civilization. A dead bird lies in state upon a bonsai-size tree. These contrasts serve to destablize any preconceptions that one might bring to this image.

The meaning and relation of the figures spread across the foreground in several scenes is opaque. Even once the viewer has identified the various players, the meaning never becomes clear. The central figure is extremely disturbing: a naked, asphyxiated woman, ashen in color, which signifies her death, is held afloat by a rope that connects other elements in the image. Next to her are Kahlo's parents, lifted and transposed from their wedding photograph; they are the only two identifiable figures,

who also appeared a year earlier in *My Grandparents, My Parents and I* (plate 1). Screened by tropical leaves is an intimate scene of two nude women (which Kahlo reworked into a larger painting the following year). Opposite them, and below the asphyxiated woman, floats the dress of a Tehuana, a costume that can be identified with Kahlo.

What the Water Gave Me affects the viewer on a liminal or even preconscious level. It functions like a dream, thus almost illustrating Freud's thesis that dream imagery is created out of conflicting desires and is often simultaneously attractive and repulsive because the underlying wish it expresses cannot be permitted its overt form. *What the Water Gave Me* is as fascinating as it is hermetic and thus it functions most convincingly as a Surrealist image in the sense that Breton articulated: through analogies it becomes a plastic manifestation of the working of the unconscious.

What the Water Gave Me was one among the twenty-five canvases Julien Levy showed at his gallery in November 1938. By exhibiting her work there, Kahlo accepted a loose association with Surrealism. Levy was the earliest American apologist for the movement but his ideas about Surrealism were less orthodox, less rigidly dogmatic, than Breton's. With his 1936 book, the first significant text in English on the subject,[45] he "wished to present a paraphrase [of Breton] which

would offer Surrealism in the language of the new world rather than a translation of the rhetoric of the old."[46] Indeed, the artists Levy showed at his gallery demonstrate his broad aesthetic permitting him to exhibit gouaches by Walt Disney, documents of Cubism, and works by the American pioneer of nonobjective painting, I. Rice Pereira, in the same season with Kahlo.[47]

Following the period Kahlo spent in New York and Paris, from October 1938 to April 1939, a change is visible in her work. This seven-month trip marks a turning point in her production and in her career. While in New York, Kahlo was commissioned by Clare Booth Luce to paint a *recuerdo* (memorial portrait) of Dorothy Hale to commemorate the death of their mutual friend. Kahlo must have worked with marked concentration, since Luce remembers making her request during Kahlo's opening on November 1, and the painting was exhibited at Breton's Mexique in Paris, which opened on March 1. However, Luce was shocked, indeed horrified, by the final result, *The Suicide of Dorothy Hale* (plate 26). She was not expecting a gruesome reenactment of Hale's suicide, but a dignified portrait worthy of a society woman, somewhat in the manner of Kahlo's own self-portraits.[48] The painting is, nevertheless, a brilliant handling of the subject. Kahlo renders Hale's demise at three moments in time, but moments that are all the more intense because of their juxtaposition. The cinematic effect — the slow-motion tumble of a body through air in front of the Hampshire House where the suicide

took place — is unique in Kahlo's work. Just as the Cubists fashioned an unprecedented sense of time and space, for Kahlo there is nothing incongruous about depicting three different points of time. It is also reminiscent of the early Renaissance convention of including several incidences in the life of a saint within a single picture.

The format of the image — the memorializing of a tragic event accompanied by a narrative — recalls the ex-voto tradition. Additionally, Kahlo's use of trompe l'oeil brings the image even more directly into the viewer's space, making it nearly impossible not to be touched by it, and further distancing it from a folk-art tradition. The clouds extend onto the picture frame, as do the tracks of blood, mimicking the blood-red paint Kahlo uses for the inscription. Hale's foot seems to extend outside the picture and casts a shadow across her name. Kahlo engages in surreality by depicting perhaps the most extreme moment of psychic torment, and yet she grounds her imagery in reality. Kahlo diagrams the dizzying process itself: an exegesis of death.

Kahlo's connection with Surrealism was provisional. Although she shared sources and, at times, subject matter, eventually she rejected any affiliation, calling Surrealism "a decadent manifestation of bourgeois art . . . a deviation from the true art that people hope for from the artist."[49] This sentiment presages Surrealism's eventual critical demise. Kahlo's fundamental objectives were worlds apart from the ideology that fueled

Plate 26
The Suicide of Dorothy Hale, 1939
Oil on masonite panel with
painted frame, 20 x 16 in.
(Frame height: 23.5 in.)
Collection, Phoenix Art
Museum, Phoenix, AZ
Gift of anonymous donor

Breton's "revolutionary" movement. Although he seized on Kahlo as the paradigm of a "natural" Surrealist, and saw in her work "a point of intersection between the political and the artistic line beyond which we hope that they may unite in a single revolutionary consciousness,"[50] Breton's point of departure, the modernized center of the world, had little to do with Kahlo's own perspective. He romanticized a revolution that Kahlo had lived through[51] in the same way that he sentimentalized the notion of femininity. What to Breton was intellectual was for Kahlo experiential.

Nevertheless, Kahlo's work first received extensive public recognition in the context of this international art movement as it manifested itself outside of Europe. Over the course of the 1940s, Kahlo's work was included in several Surrealist shows. She showed two of her largest canvases, *The Wounded Table* and *The Two Fridas* (plate 13), at the important Exposición Internacional del Surrealismo, which opened in Mexico City in 1940 and introduced the movement to the Mexican public. She sent a work to New York for the 1942 exhibition First Papers of Surrealism, sponsored by the Coordinating Council of French Relief Societies, the title of which refers to papers necessary for immigration. One of Kahlo's self-portraits was selected for the juried show 31 Women Artists held at Peggy Guggenheim's Art of this Century in New York in 1943, which, by the decisions of the jurors (including Breton, Ernst, Duchamp) was, by and large, a show of women working in a Surrealist vein. In addition, Breton reprinted his preface to the catalogue of her 1938 exhibition at Julien Levy's in his *Surrealism and Painting,* which was originally published in France in 1945.

"New World Surrealism"[52] created the conditions by which Kahlo's Mexicanidad and vocabulary became accepted. Kahlo was one among several Latin American artists crucial to the spread of Surrealism in the Americas. The notable presences of Wifredo Lam, Roberto Matta, and Joaquín Torres-García, all bona fide Modernists who were instrumental in introducing New World symbolism abroad, also disseminated the Surrealist aesthetic after the artistic diaspora precipitated by the Second World War. Exiled artistic talent from Europe included an impressive circle of Surrealists who landed in Mexico, among them, French painter Alice Rahon and her husband Wolfgang Paalen who arrived in 1939, followed by British painter Leonora Carrington, and Spaniard Remedios Varo and her husband, the French poet Benjamin Péret in 1942.[53] They did not form an exile group of Surrealists; in fact, due to the minimal interaction among them, and since each pursued his or her own brand of Surrealism, they were somewhat isolated from Mexican art, specifically the art that influenced Kahlo.

Following her return to Mexico in the spring of 1939, Kahlo painted *The Dream* in 1940 (plate 27), a work that at first glance coincides in subject matter with one championed by Surrealism: the dream world. Kahlo pictures herself asleep in her own bed, dreaming her bed freed from

Plate 27
The Dream, 1940
Oil on canvas, 29⅛ x 38¾ in.
Private collection, Selma and
Nesuhi Ertegun, New York

Figure 9
Frida Kahlo
© Bernard G. Silberstein
FPSA-FRPS

own bed (figure 9). In this "dream" Kahlo confronts what she most dreads: death. By dint of her paradoxical frame of mind, death is to be, by turns, dreaded and laughed at. In Mexico, the annual celebration of the Day of the Dead underscores these simultaneous attitudes toward death: as an ever-present reality, it is made absurd through the multiplication of its image (figure 10). These rites are neither morbid nor callous but reflect a kind of national fatalism, a black humor present in nearly all of Kahlo's painting.

After a series of debilitating surgeries beginning in 1944, Kahlo deals more consistently in her work with her physical condition. Three paintings — *The Broken Column,* 1944, *Without Hope,* 1945, and *The Wounded Deer,* 1946 — directly address her physical and emotional agony at the hands of her many doctors. Visible in each canvas are Surrealist strategies Kahlo adopted and modified in order to convey the immediacy of her personal experience. Such particularity is rarely present in the work of her French counterparts. Now more than ever before Kahlo reflects upon physical torments, which she endured for nearly a decade, inventing what has been aptly termed a "biopsychological mapping"[55] of her afflictions.

Kahlo's inventive application of a physiological vision is apparent in her arresting *The Broken Column* (plate 28). Here, and in other paintings, Kahlo continues to demonstrate her interest in expressing the outward manifestations of

earth, afloat in a cloudy sky. Above her a grinning *calavera* holds a bouquet of flowers. The strings of firecrackers that encircle the *calavera* echo the roots and vines that grow on the yellow blanket that covers Kahlo. Yellow, according to her diary, signified madness, sickness, and fear, as well as the sun and joy.[54] A second look suggests that the most compelling aspect of the image, the *calavera*, is not a Surrealist fancy, but, in fact, a part of Kahlo's own reality. Kahlo actually kept a cardboard skeleton on the canopy over her

inner feelings. Kahlo substitutes a classical column for her own spinal column, a metaphor that resonates with the Renaissance rediscovery of the classical orders, architectural principles based on the column that call for each element in a structure to bear a proportionate relationship to the whole. Furthermore, the analogy between the human body and the column was put forth in numerous fifteenth and sixteenth-century treatises and thus became the very foundation of art, just as the spinal column is the very basis of human life. *The Broken Column* is similar at one level with Magritte's fantasies: both artists integrate different levels of knowing into a single, consolidated image, physically impossible, but psychologically understandable.

Kahlo depicts two realities: she distinguishes separate kinds of information in order to render visually her own experience. She brings her intellectual knowledge of anatomy to bear upon her emotional ordeal. Using an "x-ray" vision, the result of her habitual study of physiology, Kahlo represents feelings that are otherwise inarticulable. She sees beyond (or below) the surface, as she does in *My Nurse and I* (plate 9), in which the nurse's lactating breast is shown delivering milk, and in *My Grandparents, My Parents and I* (plate 1), in which Kahlo imagines her own conception. Her biopsychological mapping thus unites the scientific with an emotional point of view.

The medical point of view allows Kahlo some distance from the excruciating

Figure 10
José Guadalupe Posada (1852-1913)
Big trolley *calavera*. A cemetery, presumably crowded with victims of the then fairly new electrical conveyances. 1907 broadside, zinc relief etching

surgical ordeals, a distance that creates a tension in *The Broken Column.* In *Without Hope* (plate 29) painted the next year, Kahlo looses a degree of control and distance. She lies, eyeing the viewer and looking trapped, encased in a blanket designed with a patchwork of meticulously rendered cells. The image is convulsive: Kahlo seems to be regurgitating, undigested, the sensations of anguish. In the cornucopia that issues from her mouth are fish, a plucked chicken, a candy *calavera,* and an unspecified mass of bodily organs or flayed tissue. It is a painting reminiscent of *Henry Ford Hospital* (plate 17): in both Kahlo uses organic metaphors to convey the inarticulable. And by depicting that which is truly incomprehensible, Kahlo exorcises these demons.

Even when Kahlo pictures herself a victim, she is defiant: through art she can react when physical circumstances prevent it. Specific details of her own predicament —the self-portrait, the noninstitutional bed,

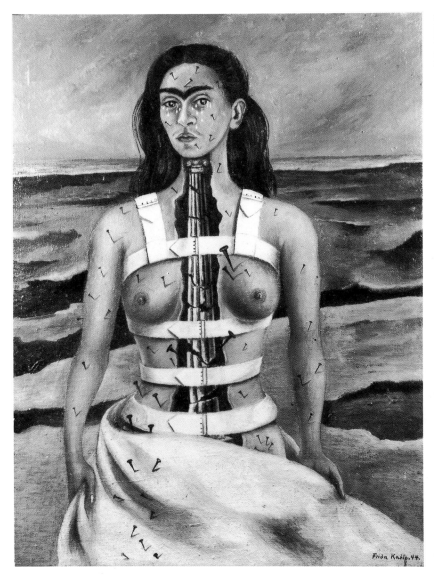

Plate 28
The Broken Column, 1944
Oil on canvas and masonite,
15¾ x 12 in.
Collection, Fundacion
Dolores Olmedo, Mexico

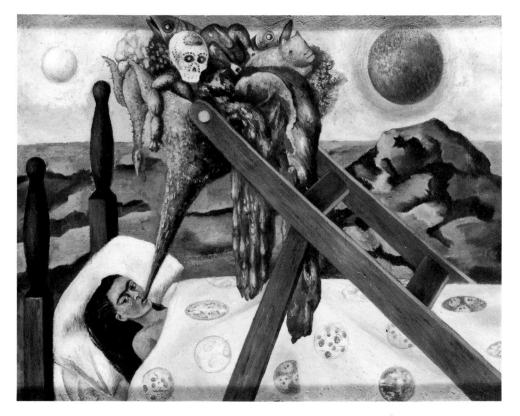

Plate 29
Without Hope, 1945
Oil on canvas and masonite,
11 x 14¼ in.
Collection, Fundacion Dolores
Olmedo, Mexico

and the wooden framework used to support canvases that allowed Kahlo to paint in bed—are set against a cosmic landscape. The sun and moon, favorite symbols of Kahlo's, which she uses repeatedly to invoke the Aztec conception of cosmic wholeness, are an attempt to place her individual misery within a universal context.

In 1946, when she painted *The Wounded Deer* (also called *The Little Deer,* plate 30), one of her most dramatic uses of the hybrid, Kahlo abandoned the realm of the physiological for the mythological. She depicts her own transformation into a deer, a hermaphroditic creature (said to have been modeled on her own pet male deer) that evokes the Aztec principles of hybridization. Quetzalcóatl, one of the most important Precolumbian creation gods, is described as the Feathered Serpent, for example. By picturing herself as a wounded deer, Kahlo invokes the realm of ancient Mexican ritual, and thus transports herself from a present-day ordeal into a mythic, earlier time. Replete with symbolism, *The Wounded Deer* remains among Kahlo's most enigmatic and uncomfortable "self-portraits." The curious central image almost defies description, and is disturbing because of the way that Kahlo reverses the ritualistic practice of humans donning a deer mask or headdress: here the deer seems to wear a Frida mask.

Kahlo's choice of a deer resonates on many levels. On the one hand, her transformation into her animal alter-ego is a concept integral to the Aztec belief called *nahualism.* Kahlo may also be making a reference to the Aztec correlation between body parts and animals. An image from the *Codex Rios* links the deer with the right foot (figure 11), the same foot Kahlo depicted in *What the Water Gave Me* (plate 25), ravaged by trophic ulcers. Deer symbolism is ubiquitous in Precolumbian culture and religion, and myths associating the deer and the hunt abound.[56] The arrows that pierce Kahlo's deer body reinforce this, while her lifelong identification with the Mater Dolorosa, often shown in Mexican retablos as wounded with daggers, is also invoked.[57]

The antlers may provide the key to aid in partially decoding Kahlo's meaning. The bony, skeletal character of mature antlers, which grow disconcertingly out of Kahlo's head, bring to mind the *calavera,* the remains of sacrificial death, a notion that may have resonated in Kahlo's mind. Moreover, the shedding of the antlers is symbolic of regeneration, perhaps a comforting thought at this time. Yet the new antlers that replace the old are extremely fragile during their growth, and they bleed easily, a fact that deepens the symbolic connection of the deer to sacrifice and blood-letting, mainstays of Aztec ritual. But the closest association is, of course, the one that Kahlo herself had made years before: the Aztec called deer tines "flowers," or *xochítl,* a name she had long ago taken for herself.

Between 1951 and 1954, the year of her death, Kahlo turned her attention to painting still life, a genre that had interested

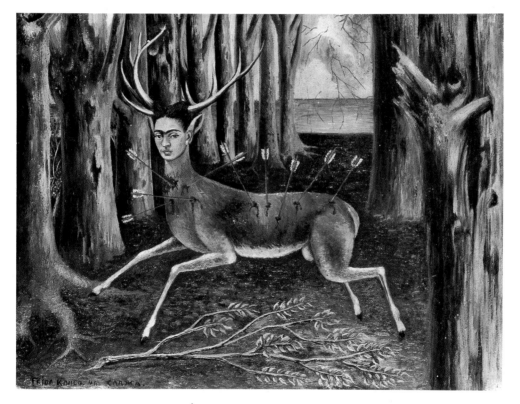

Plate 30
The Wounded Deer (The Little Deer), 1946
Oil on masonite, 8⅞ x 11⅞ in.
Private collection,
Mrs. Carolyn Farb

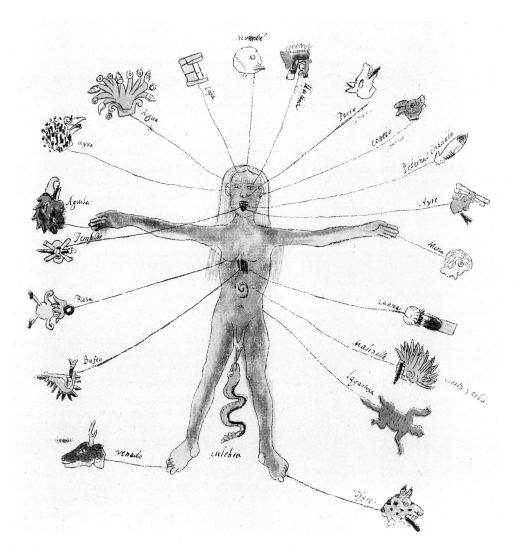

Figure 11
*Codex Rios: Il manoscritto
messicano Vaticana 3738,*
Stabilimento Danesi: Roma,
1900. Courtesy Biblioteca
Apostolica Vaticana, Ms.
Vat. lat. 3738, fol. 54r.

her periodically, but which now, in light of her physical decline, took on new meanings. After several years of desultory production, Kahlo painted thirteen still lifes over a three-year period. This extraordinary production must be seen in the context of her increasing deterioration — they constitute a kind of self-portraiture, a displacement of her own disintegration onto more neutral ground. The still lifes were a kind of relief when Kahlo found studying herself in the mirror too agonizing. By substituting fruit for her own image, she avoided confronting her condition while still producing a shocking body of work shortly before her death.

The status of still life as a genre in Europe has been subordinated to history painting and religious subjects, the consummate expressions of Western ideas. In sixteenth-century Dutch painting, the still life emerged as a subject in its own right, but its prestige languished over the next three centuries in part because it became identified as "woman's" art.[58] The Cubists, in large measure influenced by Cézanne, elevated still life to a new position of importance in the early twentieth century, both in the analytic phase of Cubism and later at the advent of synthetic Cubism, when Picasso collaged a mechanically reproduced image onto his famous *Still Life with Chair Caning* in 1912. Cubist still life, however, was as devoid of emotion as Kahlo's was replete with it. The Surrealists, on the other hand, were seduced by Lautrémont's phrase that "the beautiful was the chance encounter of a sewing machine and an umbrella on a dissecting table," and built an aesthetic on "displacement" and "dissociation." Thus, Kahlo's work is allied to Surrealist endeavors: she created meaning through the use of novel juxtaposition, although she never completely embraced the doctrine of accident. What appeared to Breton as a "chance encounter" was, in fact, Kahlo's careful culling of objects, which, when set next to each other, produced personal, albeit multivalent meanings.

Kahlo painted her first still-life oil during her visit to Detroit in 1932. *Store Window in Detroit* (plate 31) is both uncanny and humorous. Kahlo gives the image a suggestion of the surreal by juxtaposing elements of radically different sizes, and through her rendering of the deep space against which the objects in the foreground are set. *Store Window in Detroit* depicts a shop window with patriotic paraphernalia — red, white, and blue decorations, a portrait of George Washington, a medallion depicting an eagle — all on display in anticipation of Fourth of July celebrations. Perhaps it was the placid, remote look on Washington's face that caught Kahlo's eye — it must have amused her to think of this aristocratic-looking man as America's great revolutionary hero. The roaring lion, and the poised elegance of the glowing white horse, try to make up for the retiring general.

The room behind the window display appears to be relatively vacant except for some innocuous equipment used for decoration — a few paint cans, a ladder,

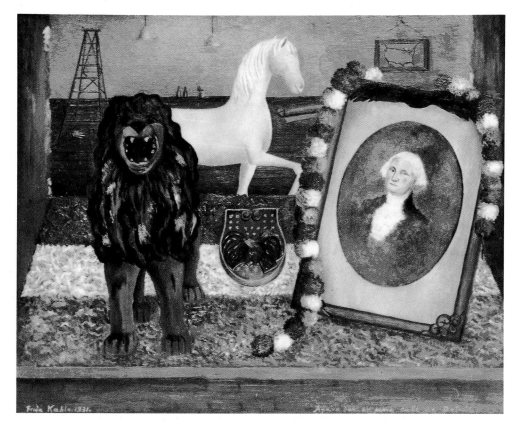

Plate 31
Store Window in Detroit, 1932
Oil on sheet metal, 12 x 15 in.
Mondlack Collection, USA

and a roll of wallpaper. But the single glove beneath the ladder contributes to the eerie feeling of this unoccupied space, and intimates that there is more here than meets the eye. It may be that Kahlo is expressing her political sentiments about the emptiness behind the upcoming patriotic celebration—the puny map of the United States seems to corroborate this interpretation.

With the exception of *Store Window in Detroit,* Kahlo's still-life paintings feature flowers and fruit, and Kahlo is always keenly aware of the specific symbolism of the plant life she depicts.[59] *I Belong to My Owner,* 1937 (plate 32), (now lost and known only through a reproduction by Kahlo's friend the photographer Lola Alvarez Bravo) is one of four still-life paintings featuring flowers alone. Kahlo took the title from the phrase painted on the common pottery vase, in which is collected a sinister-looking bouquet. Even without the benefit of viewing the actual canvas, some floral varieties pictured can be identified with certainty, and thus they help create the pervasively somber mood of the image. The central flower is a marigold (*cempoalxochitl* in Nahuatl) referred to in modern-day Mexico as the "flower of death." The marigold's ancient ceremonial significance still persists, figuring prominently during contemporary Day of the Dead rituals.[60] The flower at the top center is a member of the artichoke family, used by the Aztecs as an herb to alleviate melancholy.[61] The gloomy mood this ensemble produces through its symbolic connotations is reinforced by the animated

and visibly menacing tendrils and bristles of the other desert flowers. In contrast to these deliberately plain, even ugly, and scentless flowers, perversely antithetical to the expectation of flower painting, Kahlo juxtaposes an awkwardly positioned but delicately painted camellia. Her careful selection of floral elements is comparable to the arrangements in her self-portraits, indicating that Kahlo's still-life display is as willful as her other work. In this case, the symbolism of native flora enables her to express a sense of desolation. Thus, as the title suggests, the feelings of melancholy and of despair are Kahlo's own, they belong to their owner, whereas the lovely, sweet-smelling camellia does not.

Fruit of the Earth, 1938 (plate 33) dates from one year after *I Belong to My Owner* and is indicative of the themes that will ensue in the rest of Kahlo's still-life production. Increasingly, Kahlo's still lifes take on a sinister quality the rest of her oeuvre lacks. In this case, the vegetables undergo a disturbing anthropomorphic animation that transforms them into nonspecific genitalia. Here Kahlo shows a limited interest in biomorphism, the manner of depicting inanimate objects or even abstractions that suggest a corporal origin. The ambiguity and suggestiveness of the biomorphic shapes endow otherwise commonplace objects with a degree of the bizarre, a style that appealed to many practioners of Surrealism, in particular, Dali and Tanguy. The blatant sexual allusions apparent in *Fruit of the Earth* act in concert with multiple viewpoints to create a highly

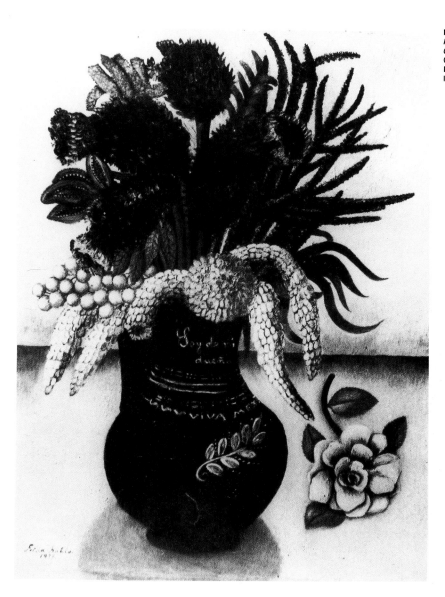

Plate 32
I Belong to My Owner, 1937
Oil on canvas
Dimensions and location unknown

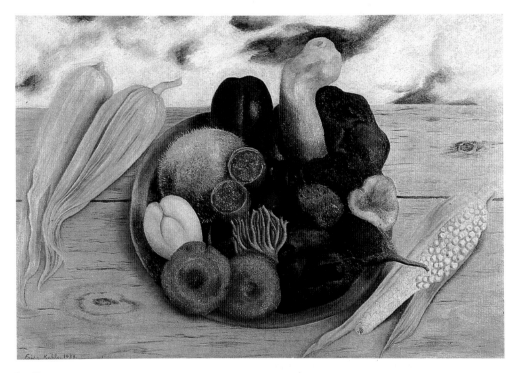

Plate 33
Fruit of the Earth, 1938
Oil on masonite, 15¾ x 23⅝ in.
Collection, Banco Nacional de
Mexico (Fomento Cultural),
Mexico

overdetermined image. Against a mottled sky, Kahlo has placed a wooden board, which acts as both a barrier and a table. Upon it is a bowl of vegetables, positioned so that the viewer sees it from a bird's-eye view. At the top is a large mushroom, whose phallus-like stalk connects the sky with the bowl. The round contours of the eggplant next to it and the white *chayote* at the left approximate sexual organs. Kahlo's reference to female genitalia is at once the most flagrant and the most visceral, placing at the center two ripe, red cactus fruits, which she paints with obvious relish.

Of all Kahlo's oeuvre, it is only in her still lifes that the truly sinister exists, in large measure due to the contrast between the innocuousness of the fruits and the double entendre Kahlo intends. Such a technique is somewhat related to Surrealism in which objects are invested with literary meanings and everyday items charged with an alternate significance by their unexpected juxtapositions.

The mysterious and ominous quality of her still-life painting also stems from the sixteenth and seventeenth-century Spanish still-life tradition through its New World interpretations. Spain's most innovative still-life painters managed to imbue mundane and familiar objects with a sense of the irrational through their resourceful use of chiaroscuro, or strong contrasts of light and dark.[62] After the decline of the tradition abroad, it lived on in colonial Mexico during the late seventeenth and into the eighteenth century. The Spanish Baroque *bodegón* (a still life consisting of food and utensils found in a cellar or tavern, i.e. the foodstuffs of peasants) spawned a variant in Mexico: genre scenes of popular life, showing a booth or market stall filled with produce.[63] The New World *bodegón* was primarily produced by untrained artists and, until recently, devalued for its lack of high-art standards.

The remnants of the mystical heritage transplanted from Spain to Mexico, as well as her focus on native crops, link Kahlo to these Mexican precursors. The meaning in Kahlo's work, however, relies less on the manipulation of light and more upon the anthropomorphic vigor with which she renders the fruit and vegetables. Nevertheless, she was not adverse to adding unrelated elements, as she did in *The Bride Who Becomes Frightened When She Sees Life Open* (plate 34) dated 1943 but begun shortly after Kahlo's return from Paris. An existing photograph of an earlier stage of the painting[64] reveals that the original image lacks four elements that appear in the final painting: a bride, who peeks over the sliced watermelon; a bright green insect poised on the bananas; an inscription below the lip of the table; and a white slip of paper with the artist's signature. It is no coincidence that Kahlo found the "bride" at the Marché aux Puces, the famous Parisian flea market where the Surrealists went in search of cultural artifacts bereft of their original context. This image may be Kahlo's response to Duchamp's *The Bride Stripped Bare by Her Bachelors, Even.* The erotic overtones inherent in the word "bride," together with

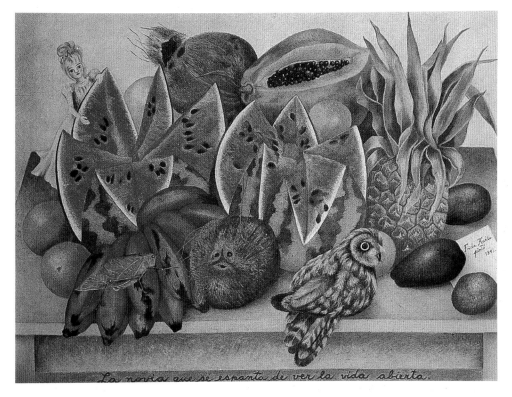

La novia que se espanta de ver la vida abierta.

Plate 34
The Bride Who Becomes
Frightened When She Sees
Life Open, 1943
Oil on canvas, 24⅞ x 32 in.
Private Collection

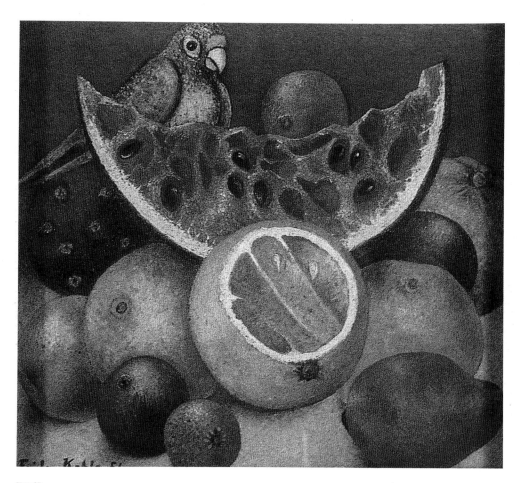

Plate 35
Still Life with Parrot, 1951
Oil on masonite, 9½ x 10⅝ in.
Collection, Harry Ransom
Humanties Research Center,
University of Texas at Austin

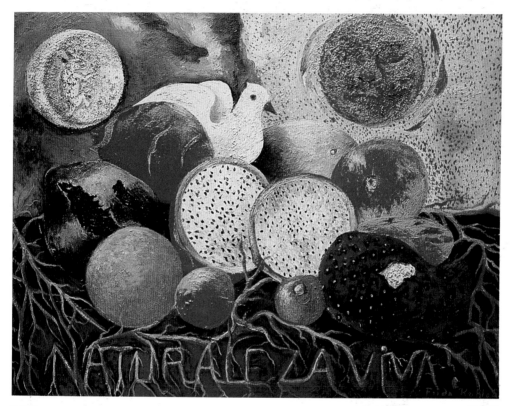

Plate 36
Naturaleza Viva, 1952
Oil on canvas, dimensions
unknown
Private collection

the overt sexual content of the split-open melons and papaya, which suggest female genitalia, create an undercurrent of violence. Additionally, the foregrounding of the ripe, phallus-like bananas, indeed the array of tropical fruit, suggests a veiled eroticism that must have appealed to Kahlo and possibly motivated her to add the doll.

Two late still lifes that seem to reflect Kahlo's deteriorating health are *Still Life with Parrot* from 1951 and *Naturaleza Viva* from the next year. Like *The Bride, Still Life with Parrot* (plate 35) displays an abundance of tropical fruit. But unlike Kahlo's other still lifes, here the fruit is partially eaten. Fruit sliced open or bursting with ripeness appears frequently in Kahlo's still lifes: fruit ready to eat, plucked from nature, consciously arranged, but not yet part of a meal. Her still-life paintings participate neither in nature, nor yet fully in culture,[65] but seem to hover between the two states.

Kahlo's still-life paintings from the early fifties function as self-portraiture. Rather than paint her own disintegration, she painted fruit and vegetables in a state of rot and decomposition. The anguish evident in a work such as *Naturaleza Viva* (plate 36) is augmented by its title. In Spanish, the term for "still life" is "naturaleza muerta," literally translated as "dead life" and figuratively as "dead nature." Kahlo's preoccupation with death, which was heightened by her confinement in bed for months at a time, led her to conceive of herself as a kind of living dead. "Naturaleza viva" translates as "living life" (or "living nature") and is Kahlo's

attempt to affirm her existence in the face of her deteriorating body.

Although it is not an independent painting, the drawing in her diary "Feet, what do I need them for, if I have wings to fly" (plate 19) is perhaps Kahlo's most powerful still life, indeed for her, a bitter memento mori. Foregoing the trappings of the traditional vanitas still life — hour glasses and skulls — Kahlo presents her two broken feet as a statue in ruins, overgrown with a prickly vine. Her disembodied legs stand poised and desolate, bleak reminders of her recent amputation. It is an image that manages to be both brutal and revelatory. Kahlo's legs, her means of movement, have now abandoned her, yet the wings of her imagination will take her where she wishes to go. It had always been the case.

Frida Kahlo faced all adversity — personal, societal, political — with tremendous inner strength. If her image "Feet, what do I need them for, if I have wings to fly" speaks to a human condition, if it transcends the personal and enters the realm of the universal, it is because through art Kahlo was able to transform her personal misfortune into accessible and meaningful icons, if not of hope, then, at least, of will.

1. *Time* (April 27, 1953): 90.

2. The Estridentista manifesto is reprinted in the appendix to Ades: 306–309.

3. Thirteen manifestos issued between 1921 and 1961 throughout Latin America are reprinted in translation in Ades: 306–337.

4. See Peter Wollen's informative essay in *Posada: Message of Mortality*: 14–23.

5. See, for example, Chadwick; and Erika Billeter and José Pierre, eds. *La Femme et le Surréalisme*. Exhibition catalogue. Lausanne: Musée Cantonal des Beaux-Arts, 1987–1988.

6. See Porter, who surveys the many opinions on Kahlo's relationship to Surrealism.

7. André Breton, *Manifeste du Surréalisme* (Paris, 1924): 24, cited in Rubin, *Dada, Surrealism and their Heritage*: 64.

8. Wolfe: 64.

9. Jean Charlot, "Surrealism — or the reason of unreason," *The American Scholar* 7/2 (Spring 1938): 230–242.

10. The problematic relation of "primitive" art to modern art has been addressed in reviews of the controversial exhibition *"Primitivism" in 20th Century Art*. See articles by Foster and Clifford.

11. See Clifford's collected essays, especially "On Ethnographic Surrealism."

12. André Breton, "Frida Kahlo de Rivera," preface, *Frida Kahlo (Frida Rivera)* (New York: Julien Levy Gallery, 1938). Reproduced and translated in *Frida Kahlo and Tina Modotti*: 36.

13. *Ibid.*

14. Ades: 308–309.

15. For a discussion of the reception of Surrealism in the United States, see *Surrealism and American Art*. Organized by Jeffrey Wechsler, with Jack J. Spector. Exhibition catalogue. New Brunswick: Rutgers University Art Gallery, 1977.

16. Gómez Arias, "A Testimony to Frida Kahlo," in *Frida Kahlo and Tina Modotti*: 38.

17. Marcel Schwob, *Imaginary Lives*. Translated by Lorimer Hammond (New York: Boni and Liveright, Inc., 1924): 130, 131.

18. M. E. Warlick, "Max Ernst's Alchemical Novel: 'Une Semaine debonté'," *Art Journal* 46/1 (Spring 1987): 61–73.

19. Herrera, *Frida*: 284.

20. Mariana Frenk, "Surrealism and the art of Ancient Mexico: Affinities and differences," *Artes Visuales* 4 (October–December 1974): 47 [English translation: 46–48].

21. André Breton, "Frida Kahlo de Rivera," in *Frida Kahlo and Tina Modotti*: 35.

22. See W[alter] P[ach]: 13. The author is in all likelihood the critic Walter Pach, a longtime friend of Rivera's.

23. Susana Gamboa, "Portrait of the Artist," *Art News and Review* (London) V/4 (March 21, 1953): 1.

24. *Posada: Message of Mortality*: 14, 15.

25. Herrera, *Frida*: 180.

26. See Susan Gubar, "'The Blank Page' and Female Creativity," *Writing and Sexual Difference,* ed. Elizabeth Abel (Chicago: University of Chicago Press, 1982): 73–94.

27. Frida Kahlo to Dr. Eloesser, undated. Cited in Herrera, *Frida*: 171–172.

28. Frida Kahlo, interviewed by Parker Lesley, Mexico City, 27 May 1939. Transcription courtesy of Hayden Herrera.

29. For a discussion of the problematic position of women in Surrealism, see Rudolf E. Kuenzli, "Surrealism and Misogyny," *Dada/Surrealism* No. 18: Surrealism and Women (1990): 17–26.

30. Herrera, *Frida*: 221–222.

31. Toor: 161–162.

32. For a historical overview of the imagery of *angelitos,* see the exhibition catalogue *Transito de Angelitos.*

33. See Toussaint's ground breaking *Colonial Art in Mexico.*

34. See Luis Cardoza y Aragón's essay "Contemporary Mexican Painting," in *Mexican Art Today*: 29.

35. *Masters of Popular Painting: Modern Primitives of Europe and America*: 9.

36. For a broad discussion of the cultural assumptions about primitive art see Sally Price, *Primitive Art in Civilized Places.* Chicago and London: University of Chicago Press, 1989.

37. W[alter] P[ach]: 13.

38. Breslow: 120–123.

39. Kahlo's opinions about *The Square Is Theirs* are taken from Frida Kahlo, interviewed by Parker Lesley, Mexico City, 27 May 1939. Transcription courtesy of Hayden Herrera.

40. J. de J. Núñez y Domínguez, "The Judas in Mexico," *Mexican Folkways* 5/2 (April–June, 1929): 90–104. This issue contains a reproduction of a painting of two Indian women by Kahlo. Kahlo is identified in the List of Contributors as a young Mexican artist.

41. Cardoza y Aragón in *Mexican Art Today:* 20.

42. *Ibid.*: 19–21.

43. Breton in *Frida Kahlo and Tina Modotti:* 39.

44. André Breton. *Surréalisme et la peinture* (Paris: Gallimard, 1965): 200.

45. Dore Ashton, *The New York School: A Cultural Reckoning* (New York: Penguin Books, 1972): 91, 94–96.

46. Julien Levy, *Memoir of an Art Gallery* (New York: G. P. Putnam's Sons, 1977): 80.

47. *Ibid.*: 296–312.

48. Herrera, *Frida:* 289 ff.

49. Frida Kahlo to Antonio Rodríguez, c. 1952. Cited in Herrera, *Frida:* 263.

50. Breton in *Frida Kahlo and Tina Modotti:* 36.

51. For a discussion of Breton's problematic use of the notion of revolution, see Margaret Cohen, "Mysteries of Paris: The Collective Uncanny in André Breton's 'L'amour Fou'," *Dada/Surrealism* No. 17: André Breton (1988): 101–110.

52. See essay by Lowery S. Sims, "New York Dada and New World Surrealism," in *The Latin American Spirit: Art and Artists in the United States, 1920–1970:* 152–183.

53. See Chadwick, especially Chapter 5 for information on the women Surrealists in Mexico.

54. Herrera, *Frida:* 284.

55. Laufer: 126.

56. Elizabeth P. Benson, "New World Deer-hunt Rituals or Deer-hunts in the New World," *Simpatías y Diferencias. Relaciones del arte Mexicano con el de América Latina* X Coloquio Internacional de Historia del Arte del Instituto de Investigaciones Estéticas. (Universidad Nacional Autónoma de México, 1988): 47–59.

57. Giffords: 47.

58. Rozsika Parker and Griselda Pollock, *Old Mistresses: Women, Art and Ideology* (New York: Pantheon Books, 1981): Chapter 2.

59. See essay by Helga Prignitz-Poda, "Wissenshaft und Pflanzen, Liebe, Tod und Teufel," in *Frida Kahlo: Das Gesamtwerk:* 35–69.

60. Durán: 102, note.

61. Helga Prignitz-Poda in *Frida Kahlo: Gesamtwerk:* 43.

62. Charles Sterling, *Still Life Painting from Antiquity to the Present Time* (New York, Universe Books, Inc., 1959): 68 passim.

63. Toussaint: 392.

64. See illustration in *Frida Kahlo: Das Gesamtwerk:* 146.

65. See Meyer Schapiro, "The Apples of Cézanne: An Essay on the Meaning of Still-life," [1968] *Modern Art: 19th and 20th Centuries, Selected Papers* (New York, George Braziller, 1982): 25 ff.

CHRONOLOGY

1521: Fall of City of Mexico to the Spanish Conquistador, Hernán Cortés

1810: September 16: celebrated as Mexican Independence Day; Miguel Hidalgo initiates the first of many popular up-risings against Spain, which ends in independence

1907: July 6: Magdalena Carmen Frida Kahlo y Calderón born in Coyoacán to Matilde Calderón y González, a devout Catholic mestiza, and Guillermo Kahlo, photographer, a German Jew of Austro-Hungarian descent

1910: Outbreak of Mexican Revolution; date Kahlo cited as her birth

1922: Attends National Preparatory School in Mexico City

1925: After January: apprentices with Fernando Fernández, commercial printer and friend of Guillermo

September 17: injured in streetcar accident

1926: Paints first oil, *Self-Portrait Wearing a Velvet Dress*

September: Alexandra Kollontai arrives, Soviet emissary to Mexico (serves until June 1927)

1927: *Pancho Villa and Adelita*

Joins Young Communist League

1928: November: depicted in Rivera's "Distribution of Arms," a fresco panel for the Ministry of Education

1929: July 6: twenty-two years old [claims that she is nineteen]

August 21: marries Diego Rivera

September 10: Rivera expelled from the Communist Party

1930: January: Kahlo and Rivera live in Cuernavaca: Rivera paints murals for American Ambassador Dwight W. Morrow at Cortés Palace

November: travels to San Francisco with Rivera; meets Imogen Cunningham

December: meets Dr. Leo Eloesser, Edward Weston

1931: *Portrait of Luther Burbank*

April: *Frida Kahlo and Diego Rivera,* wedding portrait

Mid-February: visits Mrs. Sigmund Stern, Atherton, California, for six weeks

June 8: returns to Mexico with Rivera

November: Rivera organizes show Quatro azules, (Lyonel Feininger, Alexei Jawlensky, Kandinsky, Klee) at Biblioteca Nacional de México

November 13: arrives in New York by ship with Rivera

November: exhibits *Frida Kahlo and Diego Rivera* at the Sixth Annual Exhibition of the San Francisco Society of Women Artists, California Palace of the Legion of Honor, San Francisco

December 22: opening of Rivera's retrospective at the Museum of Modern Art; meets Georgia O'Keeffe

1932: *Store Window in Detroit*
Henry Ford Hospital
Self-Portrait on the Border Between Mexico and the United States
My Birth

January: Julien Levy exhibits work by the French Surrealists at his New York gallery

April 21: travels to Detroit with Rivera

July 4: miscarries at 3 1/2 months of pregnancy; spends thirteen days in the Henry Ford Hospital

September 4: returns to Mexico by train with Lucienne Bloch to see ailing mother who dies September 15

October 21: arrives back in Detroit

1933: March 20: arrives in New York City with Rivera who receives commission to paint mural at Rockefeller Center

May: attends exhibition at Theatre Guild with Rivera. The exhibit of portraits of Jewish intellectuals by Lionel Reiss is intended to disprove anti-Semitic theories

May 9: Rivera's Rockefeller Center commission is rescinded

May 10: at a dinner given by the Menorah Writers and Artists Committee, Rivera protests the Nazi government's burning of proscribed books

May 12: General Motors cancels Rivera's Chicago World's Fair commission

June 3: Kahlo and Rivera move from Barbizon Plaza to the West Village; Louise Nevelson and Marjorie Eaton live in the same building; Rivera paints murals at New Worker's School

December 20: returns to Mexico with Rivera; they move into the double house in San Angel designed by Juan O'Gorman

1934: Summer: Rivera has affair with Christina Kahlo

July: travels to New York with Anita Brenner and Mary Schapiro

Fall: Marjorie Eaton travels to Mexico at the Riveras' request

1935: *A Few Small Nips*

Spring/Summer: moves to Avenida Insurgentes 432

September–November: affair with Ignacio Aguirre

Isamu Noguchi, in Mexico for eight months on a Guggenheim Fellowship, is one of several artists, Rivera among them, to create murals at newly renovated Mercado Rodríguez (aka Mercado del Carmen); affair with Noguchi

1936: *My Grandparents, My Parents and I*

July 18: civil war breaks out in Spain;

Kahlo and Rivera join effort to raise money for Mexicans who are fighting on the side of the Loyalists

September: Rivera joins Mexican section of the Trotskyite party, the International Communist League

1937: *My Nurse and I*
I Belong to My Owner
The Deceased Dimas

January 9: meets Leon Trotsky at his ship in Tampico; Trotsky and his wife move into Kahlo's Blue House in Coyoacán

April 10: Dewey Commission begins its week-long trial of Trotsky

September: included in group exhibition at Galería de Arte of the Department of Social Action, National Autonomous University of Mexico

1938: *Fruit of the Earth*
Xochítl, Flower of Life
Four Inhabitants of Mexico (The Square is Theirs)
What the Water Gave Me
The Suicide of Dorothy Hale

April: Poet André Breton and his wife, the painter Jacqueline Lamba visit Mexico; Rivera, Breton, and Trotsky publish "Toward an Independent Revolutionary Art," in *Partisan Review*

Summer: sells four paintings to Edward G. Robinson, her first major sale

Meets Nickolas Muray in Mexico

April 27–July 24: Masters of Popular Painting: Modern Primitives of Europe and America, exhibition at the Museum of Modern Art, New York

October: travels to New York; affair with Muray

Autumn: travels with Julien Levy to see collector Edgar Kaufmann, Sr. at his home, Fallingwater, in Pennsylvania, designed by Frank Lloyd Wright

November 1–15: exhibits twenty-five paintings at Julien Levy Gallery, New York; André Breton writes the preface

1939: *The Two Fridas*
Two Nudes in the Jungle

January: sails to Paris

February: stays with the Bretons until she is hospitalized due to a kidney inflammation; moves into Mary Reynolds' apartment; Marcel Duchamp helps arrange her exhibition

March 10: Mexique opens at Galerie Renou & Colle

April: Rivera and Trotsky reach a personal and political impasse

Summer: returns to Mexico; separates from Rivera

November: Kahlo and Rivera divorce

1940: *The Dream*
Self-Portrait with Cropped Hair
Self-Portrait with Thorn Necklace and
* Hummingbird*

Included in: International Surrealism Exhibition sponsored by the Galería de Arte Mexicano; Contemporary Mexican Painting and Graphic Art, Palace of Fine Art, Golden Gate International Exhibition, San Francisco; 20 Centuries of Mexican Art, Museum of Modern Art, New York

August: Kahlo held for two days for

questioning about the assassination of Trotsky

September: travels to San Francisco; hospitalized for tests; meets Heinz Berggruen; travels to New York with Berggruen

December 8: remarries Rivera after her return to San Francisco

1941: Guillermo Kahlo dies

Selected as one of twenty-five founding members of the Seminario de Cultura Mexicana, Ministry of Education

Included in: Modern Mexican Painters at Institute of Contemporary Arts, Boston

1942: Included in: Twentieth Century Portraits, the Museum of Modern Art, New York

October: included in First Papers of Surrealism, Sponsored by the Coordination Council of French Relief Societies.

1943: *Self-Portrait as a Tehuana*
The Bride Who Becomes Frightened
* When She Sees Life Open*

Appointed as a painting professor to the faculty of La Esmeralda, the Education Ministry's School of Painting and Sculpture; four students, Fanny Rabel, Arturo García Bustos, Guillermo Monroy, and Arturo Estrada, become known as "Los Fridos"

January: included in 31 Women at Peggy Guggenheim's Art of this Century Gallery, New York

1944: *The Broken Column*

Begins diary, which she will keep until her death

1945: *The Mask*
Without Hope

1946: *The Wounded Deer (The Little Deer)*

Awarded the National Prize of Arts and Sciences by the Education Ministry

June: travels to New York for a bone graft operation; four vertebrae are fused with a bone extracted from her pelvis and with a metal rod 15 cm. long

October: returns to Mexico

1947: *Self-Portrait with Loose Hair*

1949: January: publishes "Retrato de Diego" in *Hoy*

Readmitted to Mexican Communist Party; Rivera's petition is rejected

1950: Undergoes spinal surgery in Mexico; hospitalized for nearly a year due to an infection

1951: *Portrait of My Father*
Self-Portrait with a Portrait of Dr. Farill
Still Life with Parrot

1952: *Naturaleza Viva*

1953: "Feet, what do I need them for, if I have wings to fly" inscribed in diary

April: Kahlo's work exhibited at her one-person show held at Lola Alvarez Bravo's Galería de Arte Contemporáneo, Mexico City

Summer: gangrenous right leg amputated

1954: *Marxism Will Heal the Sick*

July 2: attends a demonstration protesting the United States' intervention in Guatemala

July 13: Frida Kahlo dies; cause of death reported as "pulmonary embolism"; suicide suspected

SELECT BIBLIOGRAPHY

Following is a list of works the author has found to be particularly useful in the study of Frida Kahlo and her oeuvre. For a fuller bibliography see Prignitz-Poda et al., *Frida Kahlo: Das Gesamtwerk* and Rubert Garcia, *Frida Kahlo: A Bibliography and Bibliographic Introduction.*

Ades, Dawn. *Art in Latin America: The Modern Era, 1920–1980.* New Haven and London: Yale University Press, 1989.

The Art of Frida Kahlo. Exhibition catalogue. Introduction by Teresa del Conde. Essay by Charles Merewether. Art Gallery of South Australia and the Art Gallery of Western Australia, 1990.

Artes de Mexico [Mexico City] 198 (1960). Issue titled "Monjas Coronadas." Various authors. English translations: 95–109.

Baddeley, Oriana, and Valerie Fraser. *Drawing the Line: Art and Cultural Identity in Contemporary Latin America.* London and New York: Verso, New Left Books, published in association with the Latin America Bureau, 1989.

Bartra, Eli. *Mujer, ideología y arta. Ideología y política en Frida Kahlo y Diego Rivera.* Barcelona: La Sal, Ediciones de les Dones, 1987.

Borsa, Joan. "Frida Kahlo: Marginalization and the Critical Female Subject." *Third Text* [London] 12 (Autumn 1990): 21–40.

Breslow, Nancy Deffenbach, "Frida Kahlo's *The Square is Theirs*: Spoofing Georgio di Chirico." *Arts Magazine* 56 (January 1982): 120–23.

Chadwick, Whitney. *Women Artists and the Surrealist Movement.* Boston: Little, Brown and Company, 1985.

Clifford, James. *The Predicament of Culture: Twentieth Century Ethnography, Literature, and Art.* See especially: "Histories of the Tribal and the Modern," (189–214) and "On Ethnographic Surrealism," (117–151). Cambridge: Harvard University Press, 1988.

Conde, Teresa del. "Lo popular en la pintura de Frida Kahlo." *Anales del Instituto de Investigaciones Estéticas* [Universidad Nacional Autónoma de·Mexico] 13 (1976): 195–203.

Dada, Surrealism and Their Heritage. Exhibition catalogue. Organized by Willian Rubin. New York: The Museum of Modern Art,1968.

Dada/Surrealism 18. Issue titled: "Surrealism and Women." (1990).

Diego Rivera: A Retrospective. Exhibition Catalogue. Detroit Institute of Arts, 1986.

Durán, Fray Diego. *Book of the Gods and Rites and the Ancient Calendar.* Translated and edited by Fernando Horcasitas and Doris Heyden. Norman: University of Oklahoma Press, 1971.

Eder, Rita. "Las Mujeres Artistas en México." *Anales del Instituto de Investigaciones Estéticas* [Universidad Nacional Autónoma de Mexico] 50 (1982): 251–260.

Foster, Hal. *Recodings, Art, Spectacle, Cultural Politics.* See especially: "The 'Primitive' Unconscious of Modern Art, or White Skin Black Masks," (181–208). Port Townsend, Washington: Bay Press, 1985.

Franco, Jean. *Plotting Women: Gender and Representation in Mexico.* New York: Columbia University Press, 1989.

Frida Kahlo. Organized and essay by Solomón Grimberg. Dallas: Meadows Museum, Southern Methodist University, 1989.

Frida Kahlo and Tina Modotti. Exhibition Catalogue. Organized by Laura Mulvey and Peter Wollen. London: Whitechapel Art Gallery, 1982.

García, Rupert. *Frida Kahlo: A Bibliography and Biographic Introduction.* Berkeley: University of California, Chicano Studies Library Publications Unit, 1983.

Giffords, Gloria. *Mexican Folk Retablos: Masterpieces on Tin.* Tucson: University of Arizona Press, 1974.

Goldman, Shifra M. "Six Women Artists of Mexico." *Women's Art Journal* 3 (Fall 1982/Winter 1983): 1–9.

Grimberg, Solomón. "Frida Kahlo's *Memory*: The Piercing of the Heart by the Arrow of Divine Love." *Women's Art Journal* 2 (Fall 1990/Winter 1991): 3–7.

Helland, Janice. "Aztec Imagery in Frida Kahlo's Paintings: Indigenity and Political Commitment." *Women's Art Journal* 2 (Fall 1990/Winter 1991): 8–13.

Herrera, Hayden. *Frida: A Biography of Frida Kahlo.* New York: Harper & Row, 1983.

————— . "Frida Kahlo: Her Life, Her Art." *Artforum* 14 (May 1976): 38–44.

Kahlo, Frida. "Portrait of Diego." Translated by Nancy Breslow and Amy Weiss Narea. *Calyx* 5 (October 1980): 93–107. (Originally published as "Retrato de Diego" in *Hoy* [Mexico City] 22 (January 1949).

Lafaye, Jacques. *Quetzalcóatl and Guadalupe: The Formation of Mexican National Consciousness 1531–1813.* Translated by Benjamin Keen. Chicago and London: University of Chicage Press, 1976.

The Latin American Spirit: Art and Artists in the United States, 1920–1970. Exhibition Catalogue. New York: The Bronx Museum of the Arts and Harry N. Abrams, Inc., 1988.

Laufer, Susan B. "Kahlo's Gaze." *Poetics Journal* 4. Issue titled "Women & Language II" (May 1984): 124–129.

Márquez, Francisco. "Frida Kahlo: ¡Viva la Vida!"

Nueva Socíedad [Carcas, Venezuela] 89 (May–June 1987): 75–81.

Masters of Popular Painting: Modern Primitives of Europe and America. Exhibition catalogue. New York: The Museum of Modern Art, in collaboration with the Grenoble Museum, France, 1938.

Mexican Art Today. Exhibition catalogue. With an essay by Luis Cardoza y Aragón, "Contemporary Mexican Painting." Philadelphia Museum of Art, 1943.

P[ach], W[alter]. "Frida Rivera: Gifted Canvases by an Unselfconscious Surrealist." *Art News* 37 (November 1938): 13.

Pernoud, Emmanuel. "Une autobigraphie mystique: La peinture de Frida Kahlo." *Gazette des Beaux-Arts* 101 (January 1983): 43–47.

Porter, Grace E. *The Fertile Torment of Frida Kahlo.* Masters thesis, University of Maryland, 1981.

Prignitz-Poda, Helga, Solomón Grimberg, and Andrea Kettenmann, eds. *Frida Kahlo: Das Gesamtwerk.* Frankfurt-am-Main: Verlag Neue Kritik, FG, 1988.

"Primitivism" in Modern Art: Affinity of the Tribal and the Modern. Exhibition catalogue. Organized by William Rubin. 2 vols. New York: The Museum of Modern Art, 1984.

Rivera, Diego. "Frida Kahlo y el Arte Mexicano." *Boletín del Seminario de Cultura Mexicana.* [Secretaria de Educación Pública, Mexico City] 2 (October 1943): 89–101.

_____ . With Gladys March. *My Art, My Life: An Autobiography.* New York: Citadel, 1960.

Rodríguez Prampolini, Ida. "Dada and Surrealism in Mexico." *Latin American Art* 2 (Fall 1990): 55–60.

Rothenstein, Julian, ed. *Posada: Message of Mortality.* London: Redstone Press, in association with the South Bank Centre, 1989.

Smith, Terry. "From the Margins: Modernity and the Case of Frida Kahlo." *Block* 8 [Hertfordshire, England] (August 1983): 11–23.

_____ . "Further Thoughts on Frida Kahlo." *Block* 9 [Hertfordshire, England] (September 1983): 34–37.

Spain and New Spain: Mexican Colonial Arts in Their European Context. Exhibition catalogue. Organized by Linde Bantel and Marcus B. Burke. Corpus Christi: Art Museum of South Texas, 1979.

Tibol, Raquel. *Frida Kahlo: Crónica, Testimonios y Aproximaciones.* Mexico City: Ediciones de Cultura Popular, S.A., 1977.

Toor, Frances. *A Treasury of Mexican Folkways.* New York: Bonanza Books, 1985 (Originally published by Crown Publishers, 1947).

Toussaint, Manuel. *Colonial Art in Mexico.* Translated and edited by Elizabeth Wilder Weismann. Austin and London: University of Texas Press, 1967.

Transito de Angelitos: Iconografía Funeraria Infantil. Exhibition catalogue. Mexico City: Museo San Carlos, 1988.

Wolfe, Bertram D. "Rise of Another Rivera." *Vogue* 92 (October/November 1938): 64, 131.

Women in Mexico/La mujer en México. Exhibition catalogue. Organized by Edward J. Sullivan. New York: The National Academy of Design, 1990.

Yau, John. "The Phoenix of the Self." *Artforum* 27 (April 1989).

INDEX